Desvigne & Dalnoky

Desvigne & Dalnoky
The Return of the Landscape

Whitney Library of Design
an imprint of Watson-Guptill Publications/New York

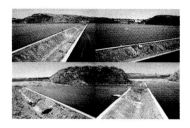

Cover: Thomson Factory, Guyancourt, France.
Drainage canals traversing the parking lot
(detail of a photomontage).

First published in the United States in 1997 by Whitney Library of
Design, an imprint of Watson-Guptill Publications,
a division of BPI Communications, Inc.,
1515 Broadway, New York, NY, 10036.

©1996 Federico Motta Editore SpA, Milano
©1997 Whitney Library of Design, English language edition

Original title: Desvigne & Dalnoky - Il ritorno del paesaggio

Direction
Pierluigi Nicolin

Editorial Supervision
Guia Sambonet

Design
Giorgio Camuffo/Gaetano Cassini

Translated from the Italian by Jay Hyams

Library of Congress Catalog Card Number: 97-60802

ISBN: 0-8230-1348-0

Manufactured in Italy

First US printing, 1997

1 2 3 4 / 00 99 98 97

All photos are from the
Desvigne & Dalnoky studio
except those on pages 19 and
20 by Charles Dard; on pages 16
and 21 by Antonio Duarte; on
pages 17, 18, 23, 24, 25, 29, 30,
31, 33, 42, 44, 45, 46, 47, 92, 93
by Gérard Dufresne; on page 90
by Claude O'Sughrue; on pages
22 and 27 from the Ville de Lyon.

The Return of the Landscape *Sébastien Marot*

For the past fifteen years, a combination of circumstances has made France one of the European nations most actively engaged in the rebirth of landscape studies within the design disciplines. At first glance, this situation may seem surprising, particularly when viewed in light of the relative disrespect that was shown in France for landscape art, as well as for the art of gardens, during the preceding five or six decades. In all probability, if questioned about that period (between the 1930s and the 1980s), nine-tenths of today's architecture students or designers would be unable to name a single landscape designer or to cite a single important project. The most widely read might recall the gardens of Villa Noailles, and the most inquisitive might refer to Albert Kahn's microcosm; but the majority would have nothing to say. And yet that period was full of creations, places that we visit but fail to recognize. Rather than disrespect, it would be better to speak of oblivion, almost as if a long parenthesis in history had been opened at that time, making us lose the habit of seeing and living within public spaces, parks, and open areas in general, such that we no longer looked on them as areas for design. In the final analysis, during that period it was almost as if the spaces around buildings and every other type of construction were no more than leftover empty areas, void and forgotten: necessary, perhaps, but relegated to the functional status of generic green spaces.

This sort of dismissal of gardens and landscaping, which took place during the same period, more or less, that the ideals of the modern movement surged to predominance and then declined, was particularly evident in France. This fact may seem odd, given that landscapists and specialists trained in the school of Alphand had been widely represented in France in the period immediately before this, particularly in those circles that not only gave birth to urban studies as a discipline but enjoyed brilliant success in exporting their methods and models (the city-garden, park systems, greenbelts, etc.).

Several general factors, related to economic and political trends, offer a basic explanation for this prolonged era of neglect; I will cite two. First of all, government interests, very much in evidence from the period of postwar reconstruction throughout the so-called "Glorious Thirty Years" until the first oil crisis in the early 1970s, followed a policy of urban and regional planning that was based almost exclusively on the development of mass housing projects and infrastructural systems. Secondly, France found itself facing, relatively late compared to other countries, the crisis of the breakup of traditional rural structures.

The combined effect of these factors — the national policy, conducted with excessive determination to create residences and services, and the conscious neglect of the economic changes taking place in the rural world — along with the absence of alternative theories from ecologists or environmentalists, accounts in large part for the one-sided success that this vision of regional management was able to enjoy for fully fifty years, being only superficially affected by the dictates of the modern movement ("from the interior toward the exterior"). This vision led to the affirmation of programs based on poor judgment and devoid of even the most elementary respect for places. Sites were evaluated in quantitative terms, as so many surfaces on which to project an image of the city broken down into its "essential functions."

By now it is a scenario that we know by heart. And we also know how businesses and public projects have come to be organized into services and specializations precisely on the basis of this clear distinction of elements and functions between the urban sector and the regional. By the time this began taking place, the new economies based on tourism, communications, recreation, distribution, and the so-called single-family home were already beginning to extend their grid into the countryside, where the structures of traditional agriculture were steadily weakening, making the countryside a vague area, undefined and without a clear future.

The final years of this one-sided construction policy (the period of the "new cities") were also the first years of today's ongoing rebirth of the landscape. This rebirth began with the attempts made by various specialists who — striving to create that "filter of vegetation" envisaged in the (often unrealized) plans for the *cité contemporaine* or the *ville radieuse* — promoted a sort of palliative to modern urbanization. Pushed into the corner by a process that looked upon landscaping as a sort of optional ingredient, the discipline of landscape design came to be more and more intimately familiar with the primary victim in this situation: the site itself. The discipline came to know the borders and edges, the areas "in between" that were neglected by designers. In so doing, the discipline learned firsthand how to take instant advantage of any opportunity to repair the damage done.

In a paradoxical way, the struggles that took place over the urbanization of peripheral areas and the *villes nouvelles* provided a sort of "on-site training" for a new generation of landscape designers. And on the basis of the experience they had gained in those struggles, these landscapists threw themselves into teaching. Many have taken their places as teachers alongside Michel Corajoud at the new École Nationale Supérieure du Paysage in Versailles, which has been transformed into a true think tank in which an alternative point of view on design is taking shape. The vision being elaborated here is not limited to merely changing the priorities; instead, it takes as its starting point not the proposed building project so much as a reading of the site itself, an examination of its possibilities. It also has a strong critical component.

During the last years of the 1970s and first of the 1980s, the development of the school in Versailles and the new approach to design that animates it coincided with an important evolution in the political-economic realities mentioned earlier. Although government policies concerning technology lost little of their authority, the move toward "decentralization" led to a proliferation of public commissions. Provinces, regions, and townships won back an impressive amount of influence in the fields of urban studies and land management and became promoters of a version of local development that is based most of all on the evaluation of sites and their local history. There is a sense in which a "landscape" can be taken as a value in and of itself; it can be presented as emblematic of what makes a given area special (in which case it is used as a showcase). Thus these new local markets, encouraged by national policies directing them to pay more attention to the environment, have opened up at least partially to the alternative approach in which greater importance is given to reading a site's resources and its historical-geographical attributes than to the bare realities of the building project proposed for the site. Riding the wave of this general movement toward an awareness of the public space viewed as landscape, landscape designers began finding themselves called upon to perform the role of stage designer for public spaces — when they weren't being put in charge of entire urban projects.

During this same period, France finally became aware of the true gravity of the crisis in the rural world, and with it the crisis in the agricultural economy. In an effort to prop up that drastically changing economy, various containment measures had been taken, and these were now revealed as totally inadequate, unable to hold back the crisis of the agrarian sector, which had been devastated by changes in small farm holdings, by abandonment, as well as by the growth of other economies still without their own authentic cultural place, their own site of settlement. The awareness gradually took hold that the legacy of those rural areas, the care for their resources, and the response to the changes in progress demanded an overall plan. The subject has led to an enormous amount of study carried on fervently at the national level as much as at the regional and local levels; its force reflects the emergence of an awareness of landscape as public space, and its requirements lead to landscape designers being assigned increasingly important roles as consultants or planners.

This new context, based on the recognition of a dialectical relationship between the respective notions of landscape and public space, explains not only the rebirth of landscape studies in France but also much of that rebirth's critical importance. For obvious cultural reasons, all contemporary European landscape designers are tied to one of two heritages, agrarian or urban, but regardless of this, those who merit particular attention are the ones who take a radical approach to the inversion of priorities effected by their predecessors and make sites and their situations the basis for any project. The specifics of site and location become the reason and raw material for projects, whose development is derived from the very fabric of the site's territory. The critical importance of this reversal is expressed in four necessary steps whose correlation, in my opinion, is of particular significance to landscape projects.

1. *Anamnesis.* This consists in looking upon an area of land or a public space as an expression of an ancient culture, as a sort of palimpsest on which one can discern the signs, visible with varying degrees of ease, of all that has transpired on the site over time and has contributed to the shaping of that specific space of landscape, to making it what it is and not something else. Anamnesis means the deciphering of those signs, stratified in the course of time, contrasting or similar, to determine those intentions and potentialities of the area that should be safeguarded and handed on. The reading is thus that of an inheritance, and the eventual project is a bequest. Although this attitude of respect for the land and the continuity it demands is by no means a prerogative of landscape designers, it does have obvious roots in landscape design theory: in the first place because the earth has its own

special nature and no one should ever meddle with it randomly, and in the second place because whatever is sown in the earth will have a long-term future that no gardener will live to see. This is the meaning of the metaphor of continuity that Michel Corajoud uses to contrast his theories to the ideologies of change or the ideologies of the tabula rasa: that of a conversation in which one cannot participate without first agreeing to listen to all that has been said up to now, and to speak up only in order to add to what has gone before.

2. *Preparation*. Since a landscape is looked upon more as process than product, any project should take on the character of an open-ended strategy. No reading of the site can ever be exhaustive, nor can it provide an "absolute image." Aware in turn of being itself in a process of becoming, a landscape design does all it can to evaluate those elements in the site that can provide indications of time, of changes in life: the cycle of the seasons, the climate, the recycling of water, the alternations of day and night, of growth and decline. By bringing these back to life, one seeks to give the residual spaces, those that have been abandoned or cast aside, the ability to revive and rejoin the present — and history — by accepting or demanding uses that are not yet foreseeable.

3. *In-depth vision*. This is the critical alternative to surface vision. The study of gardens has led to a qualitative perception of the various layers of public spaces. Rather than reading an open space as an emptiness defined by a series of surfaces and by light, in-depth vision sees the open space as a habitat in which the sky and what is underground engage in multiple relationships defined by the nature of each of them. This is a rich and complex vision, and its reading brings a project into involvement with all the layers that compose the landscape, although, of course, this involvement may be sometimes at a minimal level. The detailed identification of the qualities of an environment and its different component elements, together with analysis of their in-depth relationships, makes it possible to integrate and articulate the uses and practices of an environment, which surface vision and zoning, by their very nature, tend to separate and suppress.

4. *Relative thinking*. This final step refers to the special attention given to boundaries, adjacent areas, surroundings or backgrounds. Since landscape designers are used to working on exterior spaces and spaces adjacent to buildings, and since they are trained to revive marginal and peripheral zones (the landscaping of roadsides, of uncultivated areas, of "non-places"), they have developed to a fine art the activities of insertion, transition, and transplantation, and this leads them to prefer the relationships among objects to the objects themselves. Thus the quality of any public space depends not so much on the perfection of its buildings or its services, but rather on the quality of the relationships among them. Such relationships are constituted by transitions, sequences, visual connections, and the "calculated upgrading of adjacent areas," and it is the complex combination of these articulations that creates the overall sense of the site itself.

This "relative thinking" may well be the best summary and expression of the teachings of landscape design as they apply to the management of cities and outlying areas today, and not only because it calls on designers to consider all open spaces as relative to others, but because it proposes a thorough reexamination of exactly how any public space is used. By its very nature, "relative thinking" takes a dim view of the subdivision of small agricultural holdings, the dispersal of authority, and the breaking-up of historical relationships in the countryside, since these have been the primary agents causing the disintegration and "illegibility" of the rural landscape. In fact, "relative thinking" has led some landscape designers to reconsider their roles in general, prompting them to provide responses to requests from clients that take into consideration aspects not usually considered germane, to call attention to issues far beyond their commission, in general to transcend the limits usually assigned to such consultation in an effort to focus attention on more valid objectives. Attitudes of this sort tend to contest the system of stagnant compartmentalization and the hierarchy of responsibilities for which bureaucratic and administrative services are known. To force such clients to look upon public spaces as landscapes means forcing them to reconsider their own functions and to overcome the divisive thinking on which those functions are based; it means getting clients to allow other aims to have weight, aims that can be shared out among many people on the basis of a reworking of the way territory is directed and managed. The designs and studies of Alexandre Chemetoff are of particular relevance in this respect, since they are an example of a stance that dares to approach the provocative.

There is yet another aspect of the involvement of landscape designers in the French cultural debate that merits mentioning, since it reveals a fascinating aspect of these developments. This

is the adroitness these landscape designers have demonstrated in examining and reevaluating the history of their own discipline on the basis of the changes that they themselves have wrought. As we have seen, by a curious twist of fate, the contemporary context puts landscape designers at the convergence of the agricultural and urban traditions, which is to say they are at the center of an awareness that is directed, on the one hand, to consider public spaces (urban projects) as landscapes and, on the other, to see landscapes (rural expanses) as public spaces and therefore as possible objectives of projects. There is a name for this buffer zone: it is suburbia, that "third world" that is so vast and that is experiencing such profound changes that one forgets it possesses its own history, a history that leads back to neither the history of the city nor to that of the countryside.

But when one seeks the design tradition behind the art of gardens or the tradition behind landscaping one is forced to turn to the study of suburban design. Quite nearly all the historical reference points in landscape architecture are derived from the suburban tradition, and it is these historical reference points that have in large part contributed to the invention and formation of such forms as the French gardens in the suburbs of Paris, parks and picturesque areas, promenades outside city walls, city gardens, parkways, greenbelts, park systems. All are outgrowths of efforts made to join the urban structure more smoothly to that of the true landscape or to tighten the loosening of the connection between the city and the country brought on by suburban expansion. The hypothesis here is that the study of suburbs, as revealed by all these efforts, was the true laboratory for the study of urban planning, well before urban planning decided — and not necessarily for the better — to turn itself into an autonomous discipline by abandoning the experimental laboratory of the garden.

The most interesting aspect of the landscape studies and projects carried out in outlying areas consists precisely in this reintroduction of the long-neglected discipline of suburban studies. It is an undeniable fact that select landscape designers, linked by training to the suburban zone as the birthplace of their profession, are the only people today capable of deciphering certain sites and situations, places where other specialists see only chaos. Some areas, explain Michel Desvigne and Christine Dalnoky, "are not merely further expressions of 'urban sprawl,' but have their own history, which, while recent, is none the less rich and also diversified and

fascinating. Urban 'sprawl' is in no sense inevitable and, since there is no nostalgia here, since there is no earlier state to which we can make reference, we dream of cities rooted to their landscape, cities where one can feel the slope of a hill, sense the freshness of valleys, can follow the flow of water and the cycle of the seasons, cities in which distances can be measured, in which night truly falls, in which time is inscribed on the earth, on the skin of the landscape. To get back its dignity, architecture must learn to fight back, to hide out in the hills and struggle."

It should surprise no one that the headquarters of the École Nationale Supérieure du Paysage, the training ground for this reconquest of suburbia, is in Versailles, for that city was once the area of operations and large-scale experimentation for suburbia's first, classical conquest. It was here that Michel Desvigne studied, availing himself of the teaching of a father figure (Michel Corajoud) and the example of an older brother (Alexandre Chemetoff), and it was here that Christine Dalnoky and he set up a studio that soon won them fame as the youngest team allowed "to play with the big boys."

The design projects in this book reflect an approach that is already palpably different from that of Desvigne and Dalnoky's predecessors. It almost seems that the politics of overturning ideas, begun by the "father" and carried to extreme consequences by the "older brother," have given way to the expression of a less troubled attitude, a more serene vision that is therefore freer to adopt a tone of elegance and distinction: calm, light, erudite. An attitude, carefully worked out, of detachment; less thoroughly devoted, perhaps, but also less moralistic. Looking over these projects, one gets the impression that each plays in an increasingly explicit way with the idea that we are today living through a magical moment. It is a critical moment in which the site is no longer considered merely the landing place for a project, but begins to take on the sense of being a departure point in itself. This is a risky proposition, since there are usually no striking differences between the two situations, but it is one that Desvigne and Dalnoky seem capable of handling with unwavering care and patience. One can hope that their work will make others reflect on an observation that Gaston Bardet made in 1951 in his treatise *Naissance et méconnaisance de l'urbanisme*, when he lamented that Mansart's influence on urban planning had been imposed on history to the loss of a far better example — that of Le Nôtre.

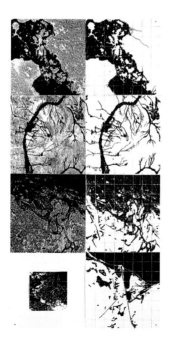

Michel Desvigne and Christine Dalnoky *Manuel Delluc*

Among the personalities who have appeared recently on the French artistic "scene," Michel Desvigne and Christine Dalnoky are an illuminating example for understanding the fundamental necessity of the art of landscape, a discipline that is still in its beginning stages. Their greatest originality consists in their having been among the first, with very few others, to apply method and logic to the pursuit of a modest undertaking while standing firm against a profound change in the status of art, and all this during a period of the general globalization of culture.

This change can be encountered, for example, in the difficulties contemporary art must face when trying to extricate itself from the morbid contemplation of its own demise. This change in the status of art is also apparent in the inability of traditional disciplines like architecture and urban planning to provide instruments and models capable of dealing with urban sprawl, which by now is escaping every form of control. The change is further revealed in the increasingly wide gap between elitist cultural productions immersed in the narcissistic contemplation of their own spectacle (such as Christo's packagings) and the increasing hegemony of an instantaneous, mass culture driven by new forms of media. And that mass culture, far from entrenching itself behind some reassuring theory of what art, culture, or society should be, shows itself to be rigorously capable of adapting to what art and culture really are in a society dominated by the paradigm of communication.

In this society, all attempts by art to achieve some general, explanatory model are thwarted by the possibility, unthinkable until just a few years ago, of communication among all models in a gigantic monadology of multipolar exchange. At that point contemporary art, bound by its bias toward an individual artist or work, or toward the production of a particular model of meaning, soon reaches an impasse within a culture that discovers ecstasy in the very annihilation of meaning.

It is here that landscape art steps back onto the stage, reminding us of how, with its bare reality, it has withstood the dispersing of the mythical tales of meaning. By now, the question of meaning has become completely joined to the unrestricted opening to all the world's happenings within a reality freed from all metaphysical depths — but not, for that reason, unaware of

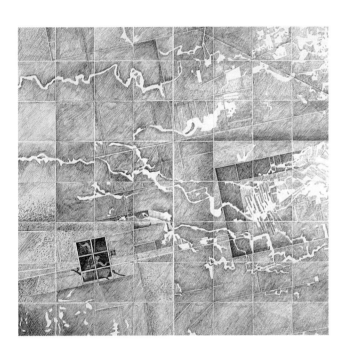

the multiple paths of meaning that went together to form the history of culture until the end of this century.

The fact that Desvigne and Dalnoky interpret the current historical moment with such vigor is the result of an interpenetration of life and work, the route of their lives and the experience of their work. Their creations are original works, not makeshift productions, and as such are constructed methodically on the basis of a personal drive that rules out any imprecision. In retrospect, every step along the route of their lives seems necessary to the creation of their overall polemic. And as an itinerary it merits being followed with attention, since each of its stages is a sure guide to the achievement of the final aim.

Born in 1958, Michel Desvigne was first drawn to the natural sciences, but later turned to landscape studies at the École Nationale du Paysage in Versailles, where he enrolled in his senior year. For her part, Christine Dalnoky, born in 1956, studied architecture at the École Nationale Supérieure des Beaux-Arts in Paris before deciding, in 1978, to move to the Versailles school. The school's location was not unimportant in terms of the students' training. The nearby gardens of the palace, designed by Le Nôtre, offered them direct experience of the subject matter of their studies. A fusion of "academic" training in the various theories and techniques of landscape art with in-situ experience, the school's teaching presented a concept of landscape based on the contiguity between knowledge and its object. With its impulse provided by the outstanding personalities of Michel Corajoud and Alexandre Chemetoff — professionals, theorists, and teachers, as well as initiators of the "landscape design" rebirth in France beginning in 1973, the year of the school's foundation — this new approach to the discipline, inspired by phenomenology, expresses the ambitious aim of never confining landscape to a merely "decorative" role.

From 1983 to 1986, Desvigne and Dalnoky completed their studies with a series of collaborative activities connected to the studios directed by Chemetoff and Corajoud. The phenomenological approach is based on the concept of memory. Well before becoming the object of a design project, a landscape is the bearer of a complex memory that is preserved in its every aspect. The landscape designer's art thus consists in first observing the given landscape and then knowing how to discern the reasons behind its particular formation, so that those same

factors can then be employed as elements in the design. This is why landscape design is not called an art of imagination or creation, but an art of memory.

In 1986 and 1987 respectively, Desvigne and Dalnoky experienced a kind of emancipation when they became the first landscape designers to win the competition held by the Académie de France in Rome, and they found themselves living in the Villa Medici. Christine Dalnoky began researching the relationships between architecture and landscape by way of the study of five Italian Renaissance gardens: the Bosco Sacro of Villa Orsini, the gardens of the Piccolomini Palace, Villa Medici, the Villa d'Este, and the Farnese garden. In these gardens she examined the ongoing dialectic between the elaboration of the "ideal" geometric forms that determined the layout of the garden, and the individual particularities of the ground on which the layout had been inscribed. In each case, this identification of the place of intersection between what was projected from the designer's imagination and the topographical reality it had to match, led her to the further identification of the living memory of the project.

Michel Desvigne's study also began with the observation of a landscape, in this case the islets formed as a result of alluvial deposits in a stream bed. Desvigne used this study to elaborate a demonstration analogous to Dalnoky's, but the thinking behind his method moved in the opposite direction to her's. He proposed using a movable bulkhead to alter the process of the formation of the sand deposits, moving it around to make modifications as desired at any moment: the construction would cyclically create new forms while involving the same number of islets. The simple manipulation of a natural phenomenon was thus transformed into an aesthetic creation. This no longer involved "natural" determinism, as in the study by Dalnoky, but rather "cultural" determinism, since it was directly related to the intervention of a human hand in a natural process. Inversely, the "beauty" invested in the aesthetic project was none other than that provided by nature itself — specifically, the shape of the islands — a beauty that could be "objectively" revealed in satellite photographs.

Stripped of all aesthetic concerns, the methodical radicalism of Desvigne and Dalnoky would seem to follow a route very similar to that followed by contemporary art. But as close to each other as the two positions are, they are nonetheless irreconcilable.

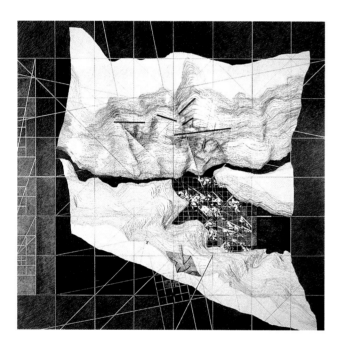

When its content is systematically reduced to its primary state as pure representation, contemporary art always ends up running into the question of the purpose of its existence. In contrast to this, the creation of a landscape designer shares its origin with a "landscape," which in and of itself has a purpose, and thus the landscape designer's creation by its very nature has the basic support of a sensible reason for existing in the world, being at least operational, if not useful.

The fundamental encounter is thus the encounter with architecture. The two disciplines have at least one essential fact in common: action. It has not been by mere chance that Desvigne and Dalnoky have associated themselves with architects for whom action is more important than meaning, for whom *techne*, in the original sense of a craft or skill, counts more than art. First among these is the Italian architect Renzo Piano, a master carpenter and a leading example of the extraordinary ability to rationalize the design process. This ability, enjoyed by Piano and his ilk, opens the field to the pure pleasure of constructing the world we live in, rather than limiting the architect to philosophizing. "There is only one world, not two," Piano once remarked to Michel Desvigne, meaning by that statement to find fault with the sometimes overly ideological inclinations of some Frenchmen. He may also have been addressing this criticism to his own country, which inhabits the second world, the one of memory and culture, far too stubbornly to show any real warmth for his work. So goes the eternal conflict between *techne* and art, between Leonardo da Vinci and Michelangelo. The relationship Desvigne and Dalnoky have with Paul Andreu is of equal importance. An engineer from the École Polytechnique, he anticipated by twenty years any kind of "communications architecture" (from a Koolhaas or a Nouvel) when he created a powerful architectonic communications tool: the Charles de Gaulle Airport. With the airport's eventual link-up to the Roissy station of the TGV (high-speed train), designed by Jean-Marie Duthilleul, architectural engineer of the SNCF (Société Nationale des Chemins de Fer Français), Andreu's famous terminal — designed as a highway junction — will be permitted to express its full potential. And there is, finally, Norman Foster, from whom Desvigne and Dalnoky learned, aside from the love of building, some of that typically English taste for territorial conquest.

Given their special interest in useful projects, it was inevitable that

Desvigne and Dalnoky would eventually turn to public commissions. Creating designs for public spaces involves forcing the design to adhere to imperatives that transcend the work itself and legitimize its existence. Working for the public also lets the designer place the project among other long-lasting creations. The work is thus in a position to create culture — and not on a merely metaphorical level, but as a matrix of the voluntary reworking of the landscape, of the "first" world. From first to last, this is the world we must relearn to cultivate, and not through the mere act of preservation (Desvigne and Dalnoky are not ecologists) but by way of improved knowledge and mastery of its rules and formations. Desvigne and Dalnoky work with their world as it is understood in the broadest sense: urban or outlying urban areas waiting to rediscover a "legibility" they lost long ago (Montpellier, Lyon, Nîmes) and external infrastructures (highways, railroads, airports) that must be studied with due respect before they can be remodeled to better perform their functions.

As we have seen, design projects always move forward from what is still legitimate, from memory. And this is never nothing, unless it fails to become a positive force capable of reproducing itself. "The new does not exist in what is said, but in the event of its return," wrote the philosopher Michel Foucault, thus paraphrasing a celebrated directive of Nietzsche: "Become what you are!" And thus the landscape designer, as understood by Desvigne and Dalnoky, is not like the painter who sets out to combine in his painting the landscape and a presentation of the landscape; instead, the landscape designer is first of all the guarantor of the authenticity of the landscape on which he or she acts, changing it. "Building a 'pretty' land would be very strange," observed Michel Desvigne. It is precisely from this authenticity that memory draws the ability to perpetuate its legitimacy, and culture finds the power to create new values from the same source.

If Desvigne and Dalnoky take as their starting point the rejection of everything that serves no real purpose, and if they strive to anchor their works in the solid, real terrain of the first world (as opposed to the second, the world of art), then they deserve much credit for having had the sensitivity to never allow that achievement to lead them to a kind of blind empiricism; they have never let it make them forgetful of the fact that humans are beings gifted with liberty. The age-old struggle between

man and nature, the conflict between reason and emotion, is the second great basic force behind their work, coming right after memory. It appears in a wide variety of projects, particularly those involved with public spaces, from the garden of Issoudun (page 42) to that of the Caille public garden in Lyon (page 28) and the internal court at rue de Meaux in Paris (page 16), all works characterized by a constant contrast of natural elements with constructed elements. When freed of all subjective or cultural connotations, both natural and constructed elements seem to return to a primordial state: the beauty of "pure" nature contrasts with the beauty of manufactured "purity." Regardless of their perfect symmetry, the two terms do not really constitute the opposing faces of a single "phenomenological chiasmus." In this case, art limits itself to casting the manufactured in the role of perfect stand-in, of the minimal sign of a nature that, despite its own appearance — or precisely because of it — is not in reality any less artificial than the manufactured, in the sense that awareness of it is subject to the perception of the user and the design of the landscape designer. This double nature of what is and what is perceived (object-subject) appears in every instant, but it appears at the level of pure presentation only in the mind, and thus does not lend itself to any designation, other than by such indirect terms as "manufactured stand-in."

This explains why, despite their specialization, Desvigne and Dalnoky are not particularly sedentary (although it could be said they are absolutely sedentary in the sense that they inhabit an immaterial space, that of the mind). When they finished their studies, it seemed obvious to them that they should set themselves up in Versailles, a few hundred yards away from the school they had attended. Why move farther away? Today, with the increasing number of commissions, their growing fame, and even their very activity as teachers, they have the opportunity to lead lives in continuous movement, without ever setting their feet on the ground. This freedom, this lightness of being — modern and eternal — gives an unexpected, modern spin to a phrase from Plato that seems coined for the ideal landscape designer: "Man is a tree whose roots grow toward the sky."

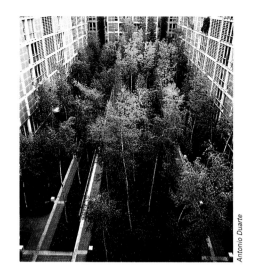

Antonio Duarte

Internal garden of a condominium in rue de Meaux, Paris. In the courtyard of an apartment complex built by Renzo Piano in Paris's XIX arrondissement, a "transplanted" patch of authentic landscape brings to life an area that was originally empty. The carefully restrained growth of the vegetation matches and complements the buildings' rational design. A carpet of creeping honeysuckle covers the area, creating a background for scattered stands of birches whose silvery trunks give the space a crystalline light. This woodsy atmosphere confers a certain privacy on the buildings despite their close proximity to one another. Except for the necessary access routes, no structures or ornaments have been permitted to disturb this contrast between the natural and the architectural. The ground is broken up slightly to reinforce the sense of a natural landscape. An access ramp raised slightly above the garden emphasizes its artificial, but not picturesque, character: it is an area of reconstructed nature, and is thus a true amenity in an urban setting. **17,485 sq ft**

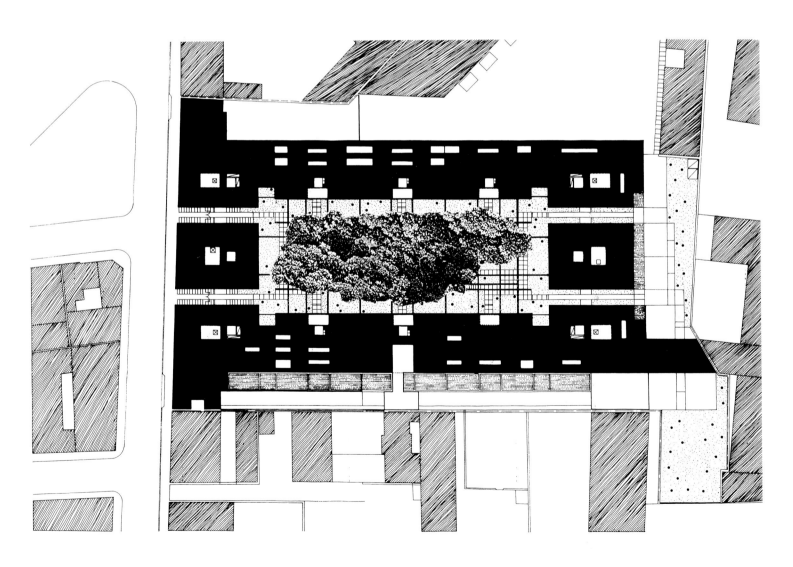

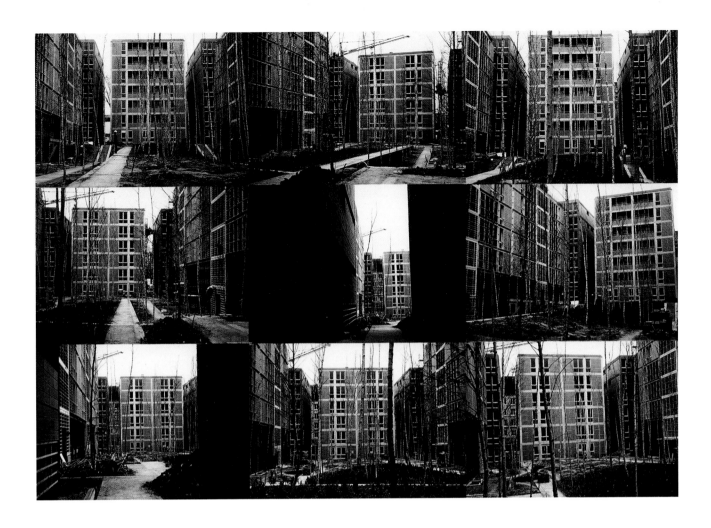

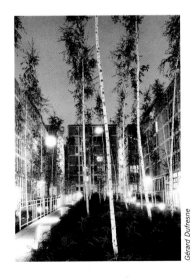

Gérard Dufresne

View of the garden from a typical apartment (opposite top). Site plan (opposite bottom). The garden occupies the entire area of the courtyard. The random plantings of the birches contrasts with the rational geometry of the buildings designed by Piano.

The courtyard during construction (above). View of the garden (left). The verticality of the birches contrasts with the horizontality of the creeping honeysuckle groundcover.

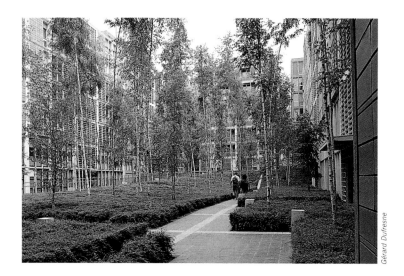

Gérard Dufresne

The paved walkways and lighting fixtures are of a simple design, minimal and economical (left). The lighting fixtures are made of cement, the pavement is brick (below), as is the cladding of the façades.

The paved paths are designed to create a sense of continuity with the surrounding architecture (opposite).

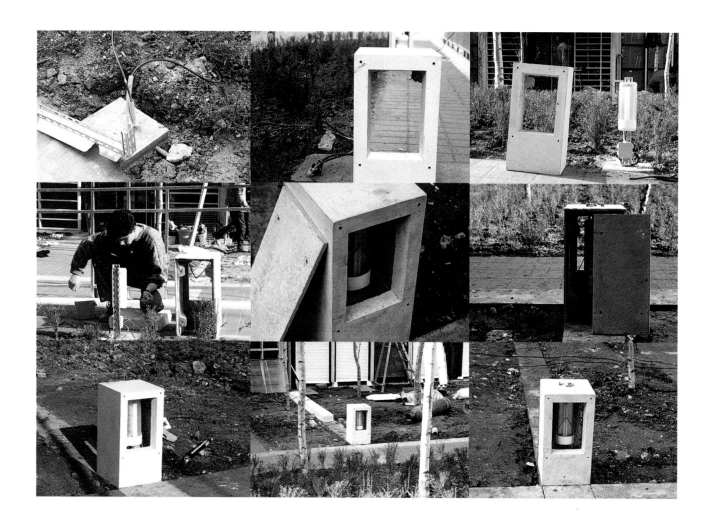

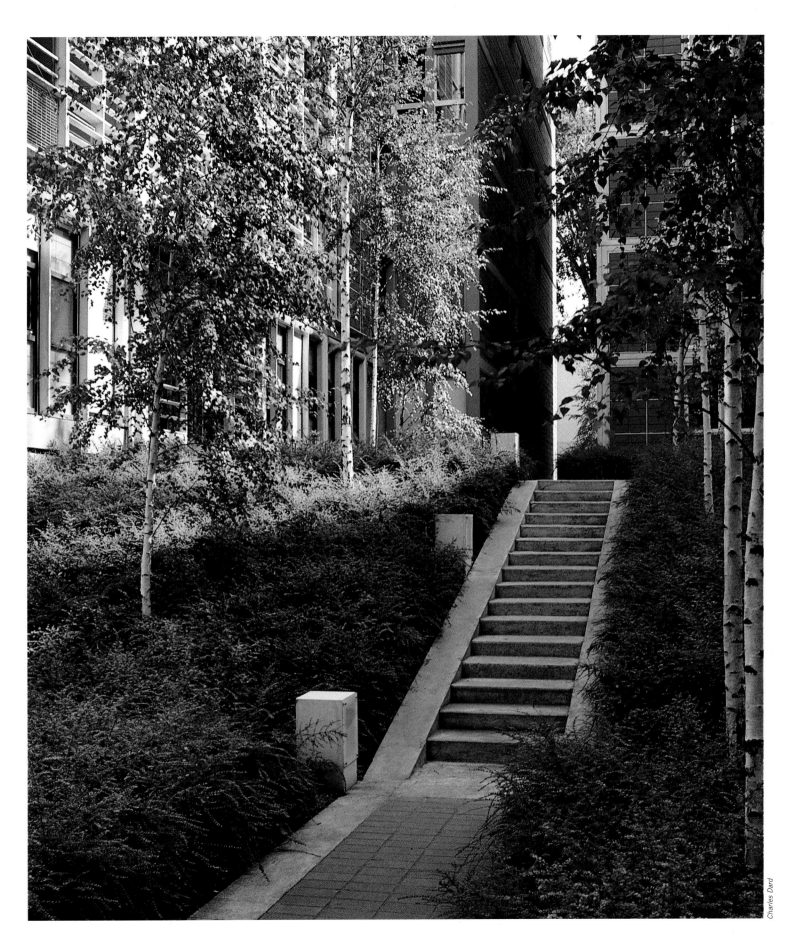

A raised ramp runs across the garden (right).
Longitudinal section (below).

Views of the birch stands (opposite).

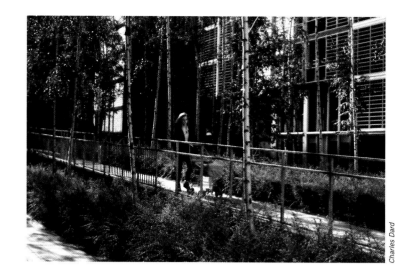

Charles Dard

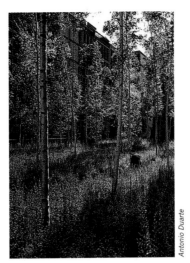

Antonio Duarte

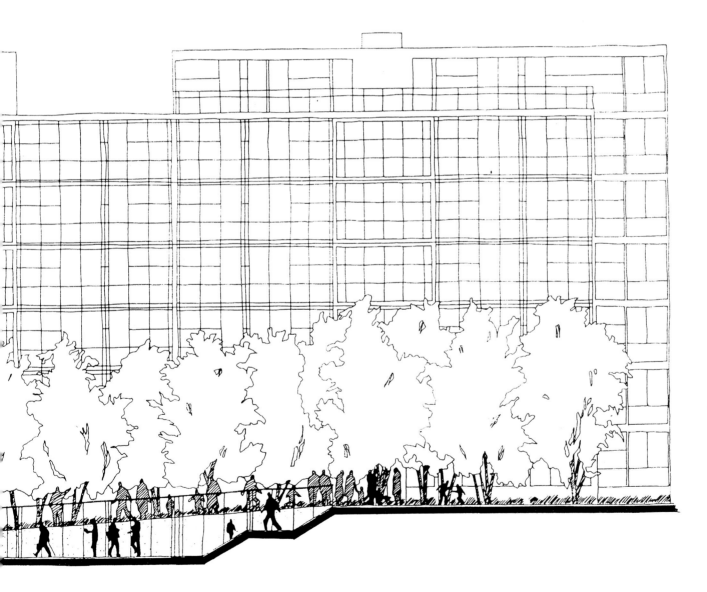

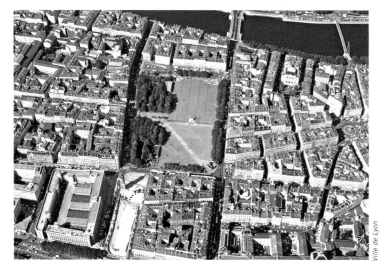

Ville de Lyon

Place des Célestins, Lyon. Designed as both a city garden and a piazza in front of a theater, the basic layout of Place des Célestins is defined by a large limestone base connected to street level by a pair of steps, also made of pale limestone. The geometric form of the garden results from the disassembling and adopting of elements drawn from the orderly façade of the 17th-century theater: four bands of vegetation (or, on one side, of water) delineate a square-shaped wooden platform. Each of the bands is broken by a narrow opening, and the four openings form a cross whose extended axes converge on a periscope by artist Daniel Buren, that offers a view of the entrance to the parking area underneath. The bands running perpendicular to the theater are planted with particularly showy, flowery vegetation (in contrast to the rather meek plants used in traditional decorative parterres); these serve to isolate the square from vehicular traffic. The bands parallel to the theater are more subdued: in the band farthest from the theater's façade, a blanket of rhododendrons defines the boundary of the garden but does not in any way prevent a clear view of the public edifice. The band closest to the theater is formed as a classic "reflecting pool" that extends the garden toward the theater's monumental stairs. **38,736 sq ft**

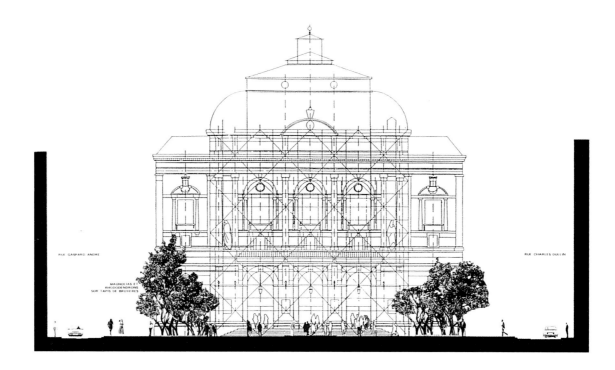

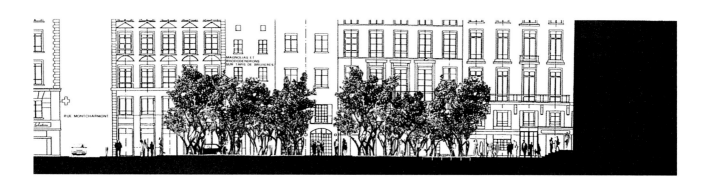

Aerial view of the square and the theater
(opposite top).
Cross section of the square with the façade
of the theater (opposite center).
The streetwall on one side of the square
(opposite bottom).

View of the square in afternoon light (right).
Site plan of the garden (below).

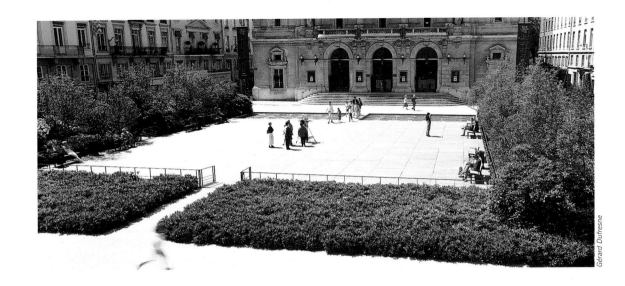

Gérard Dufresne

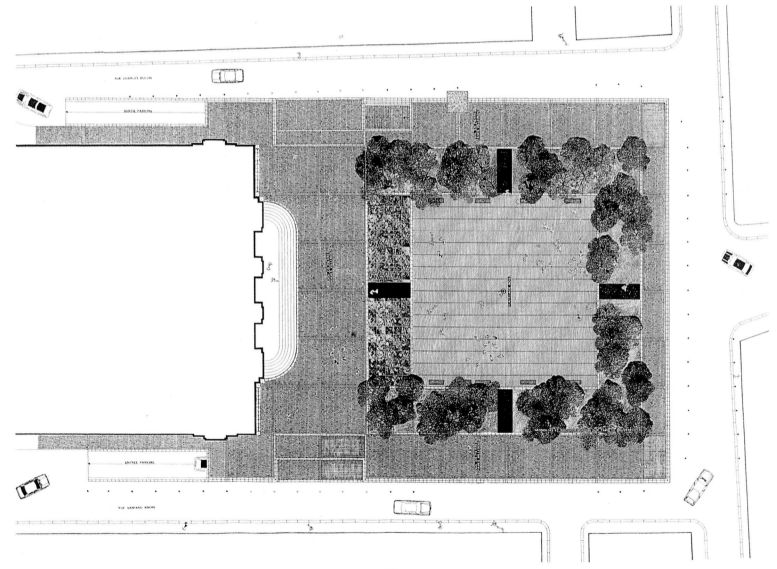

The square fronting the theater (below).

View of the square from the theater (opposite top). The ponds separate the steps of the theater from the square.
Side view (opposite bottom). Extended perimeter steps form the raised base of the square.

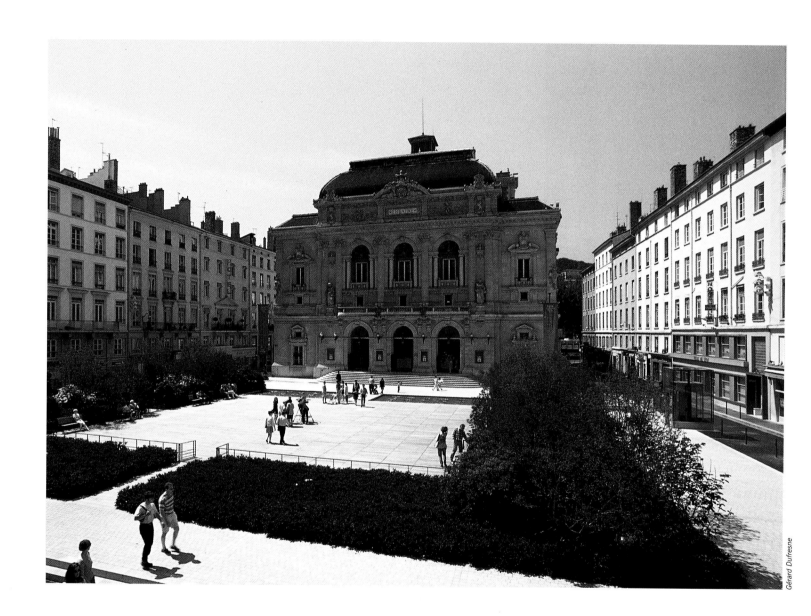

Gérard Dufresne

24

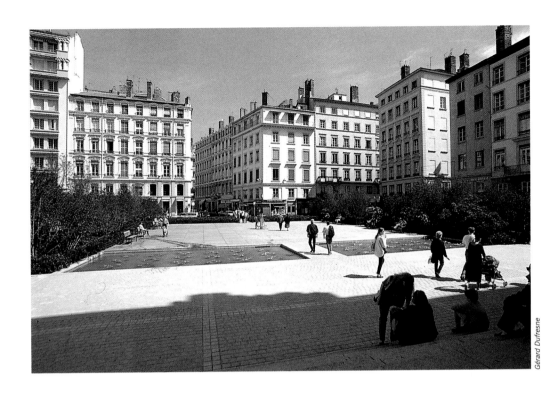

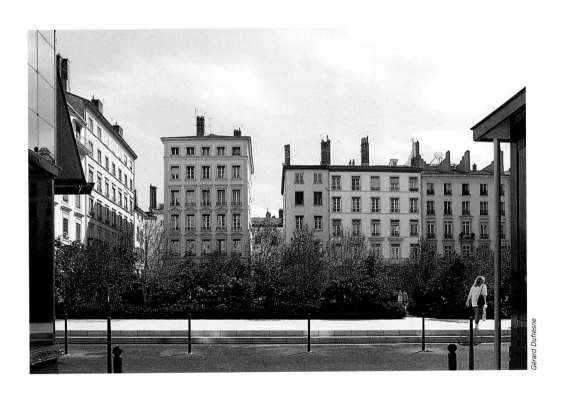

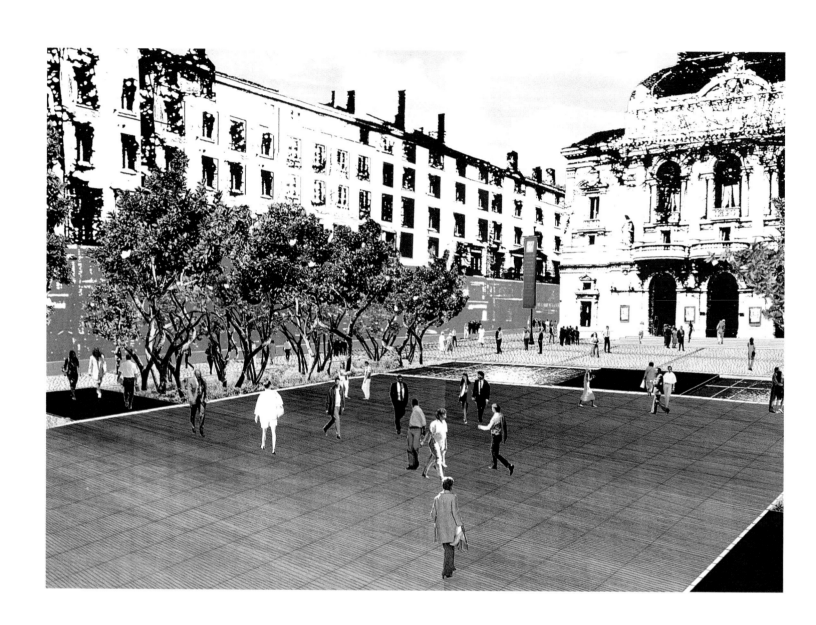

Perspective rendering with mature plants (opposite).

Views of the garden (right and below).

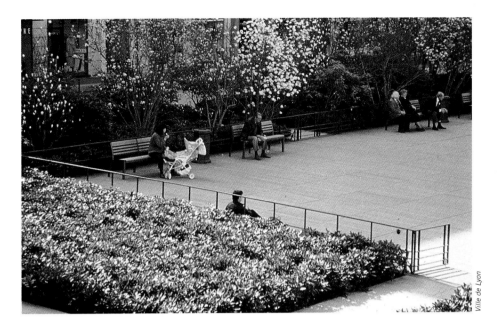

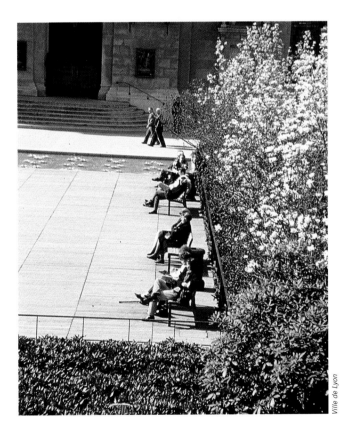

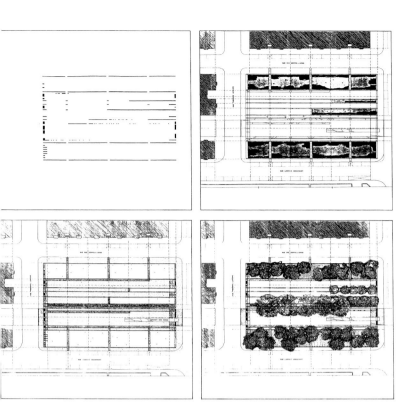

René et Madeleine Caille public garden in the États-Unis Quarter, Lyon.
The garden is located in the middle of the États-Unis Quarter, which was designed in the 1930s by Tony Garnier, and it follows the main compositional lines of that design. It also draws inspiration from another Lyon project by Garnier, the garden on the Isle of Cygnes in the Rhône, from which it takes the motif of a central area flanked by two parallel bands of vegetation. The use of bands gives a sense of order to the design while also permitting an effect that is both unitary and diversified. A preexisting row of plane trees is taken as the center of the design; the area on each side of this row is divided into two large bands. The first of these is exposed to traffic and suggests a continuation of the avenue that traverses the quarter. The second band, farther in and protected from the surrounding buildings, is arranged as a garden, an important amenity in a working-class quarter in which there is a large number of children. The minimalist urban structures and the luxuriance of the plants fit together harmoniously. The lighting fixtures are never directly visible: they reside in small pillars located beneath the trees or in fixtures hidden in bushes behind the benches. The materials used are simple: red gravel for the large surface areas, plain cement for benches and paths, pebbles for the drainage canals. The use of this combination garden-city square — facilitated by the existence of a separate municipal office for public spaces and park areas — presents a halfway point between the modernist demand for a total "green space" and the rigid Haussmannian subdivisions of public spaces in squares, gardens, and streets. **43,040 sq ft**

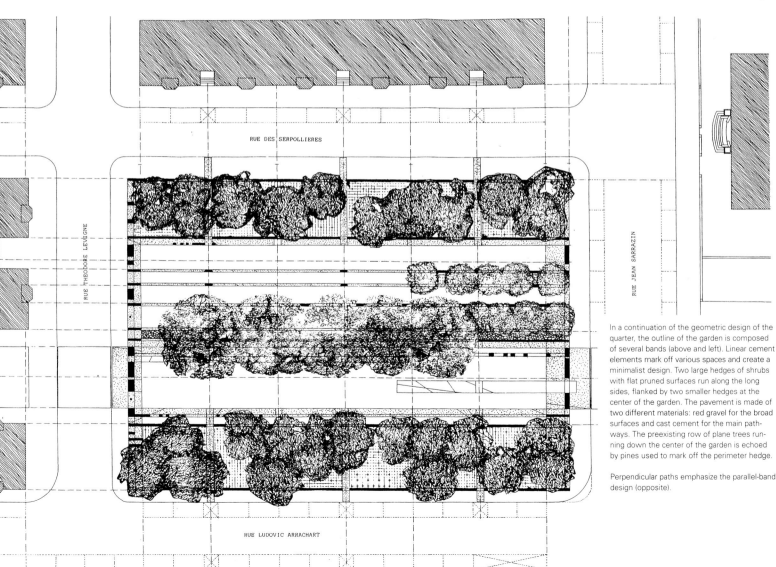

RUE DES SERPOLLIERES

RUE THEODORE LEVIGNE

RUE JEAN SARRAZIN

RUE LUDOVIC ARRACHART

In a continuation of the geometric design of the quarter, the outline of the garden is composed of several bands (above and left). Linear cement elements mark off various spaces and create a minimalist design. Two large hedges of shrubs with flat pruned surfaces run along the long sides, flanked by two smaller hedges at the center of the garden. The pavement is made of two different materials: red gravel for the broad surfaces and cast cement for the main pathways. The preexisting row of plane trees running down the center of the garden is echoed by pines used to mark off the perimeter hedge.

Perpendicular paths emphasize the parallel-band design (opposite).

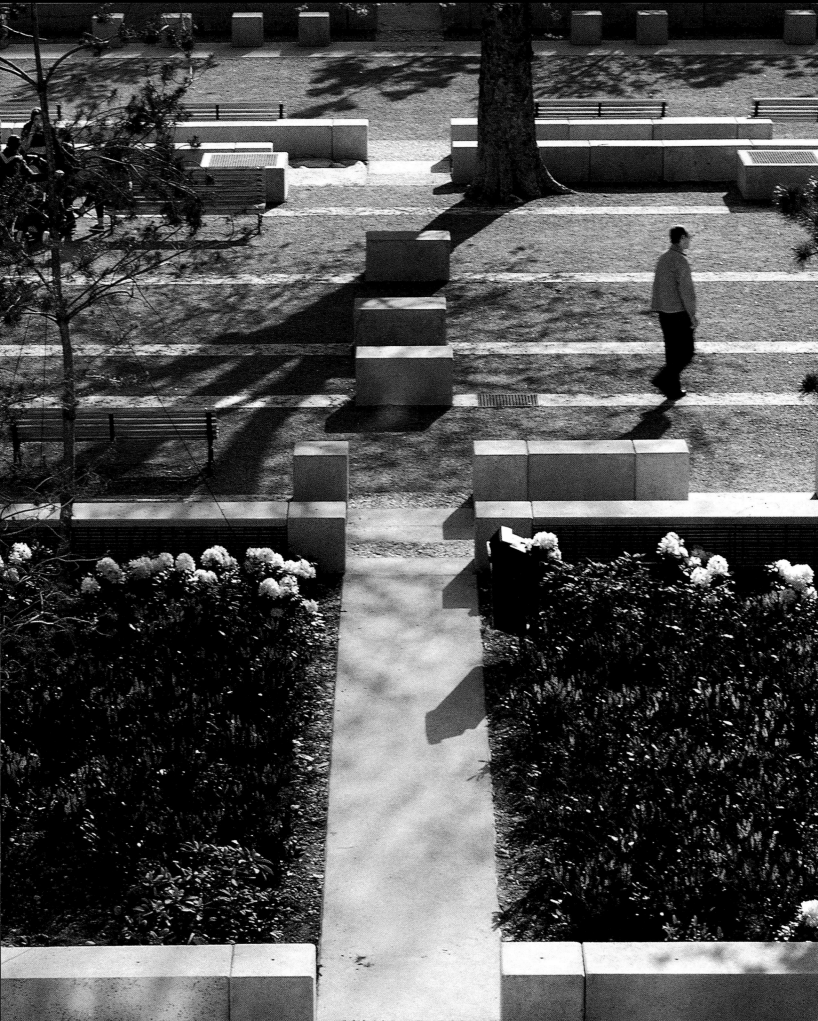

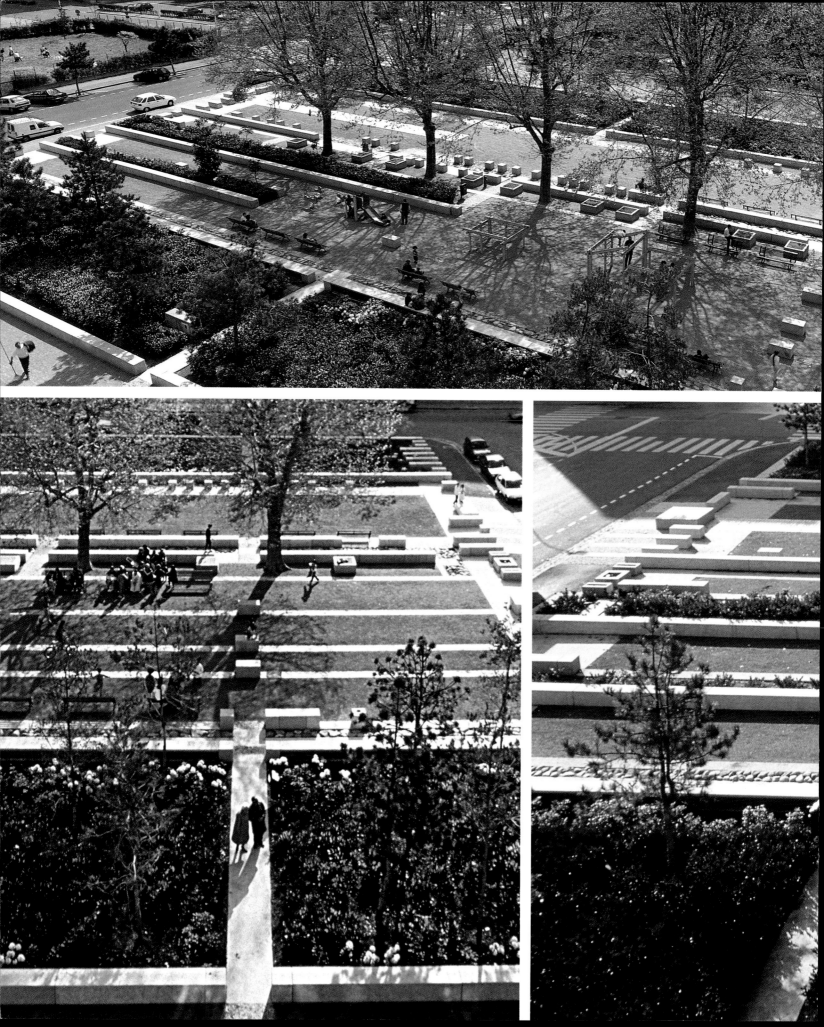

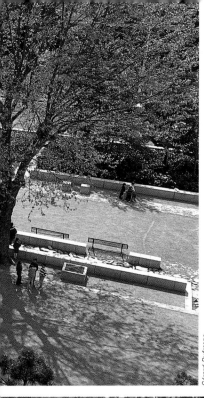

The preexisting row of plane trees marks off two different areas: one a garden, the other serving as a city square that culminates the avenue that crosses the quarter.

The garden designed by Tony Garnier on the Isle of Cygnes (right top) and the layout of that garden transposed onto the site of the Caille garden in the États-Unis Quarter of Lyon (plans, right).

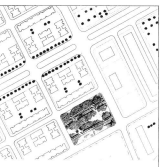

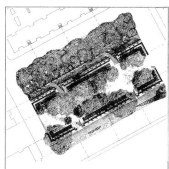

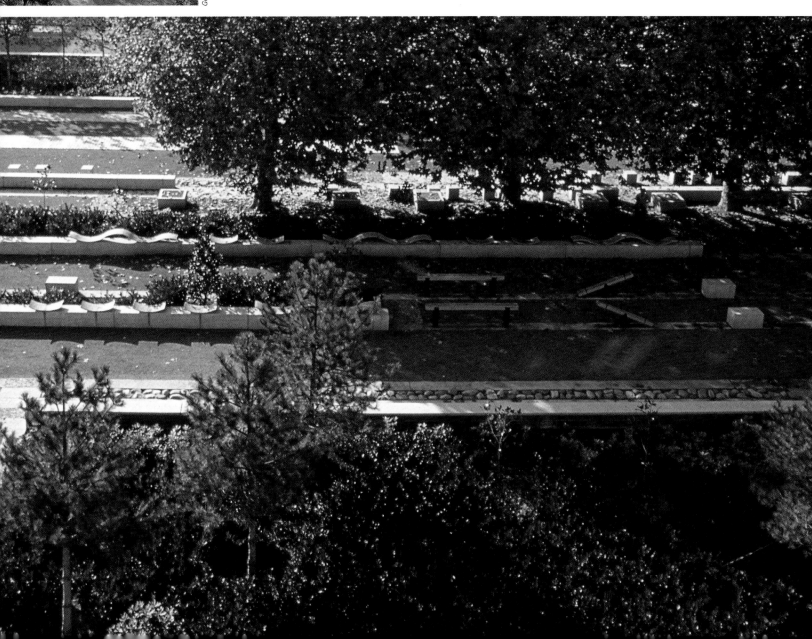

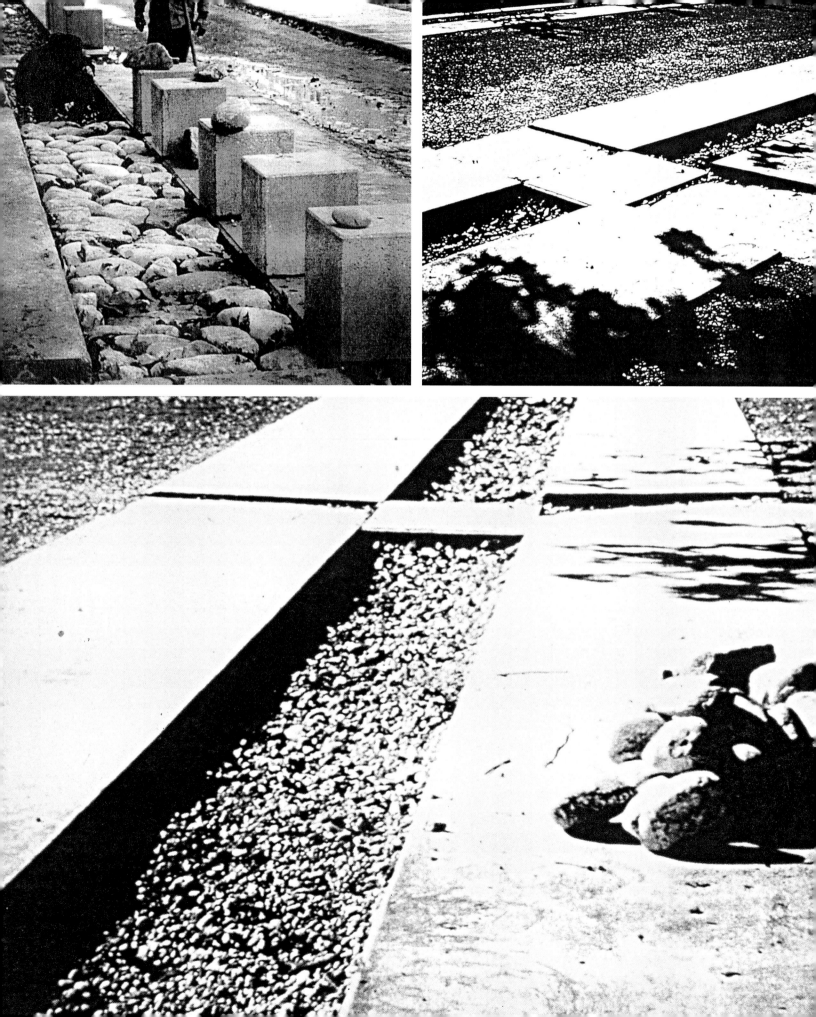

The drainage canals during construction (opposite). The use of pebbles evokes the aesthetic of a Japanese garden.

Blocks of smooth cement mark the boundaries of various parts of the garden (right).

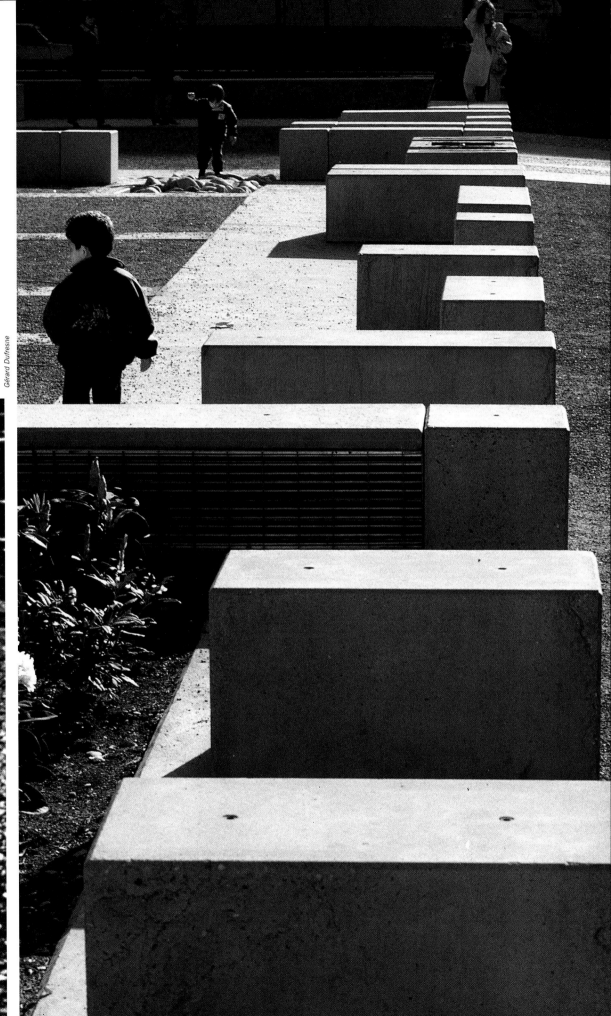

Gérard Dufresne

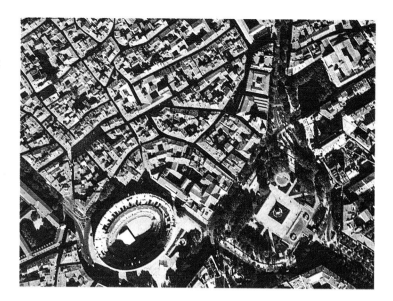

Square de la Couronne, Nîmes. This project involved transforming an old-style city garden into a square, and doing so as simply as possible. The master plan consisted of reversing the original layout: where the garden involved an empty central space framed by vegetation, the square uses a hardscape perimeter set around a central parterre. The preservation of the preexisting plane trees, and the necessity of making use of the raised existing base, imposed the solution of a "porous" perimeter wall with stone steps used to compensate for the difference in level. **48,205 sq ft**

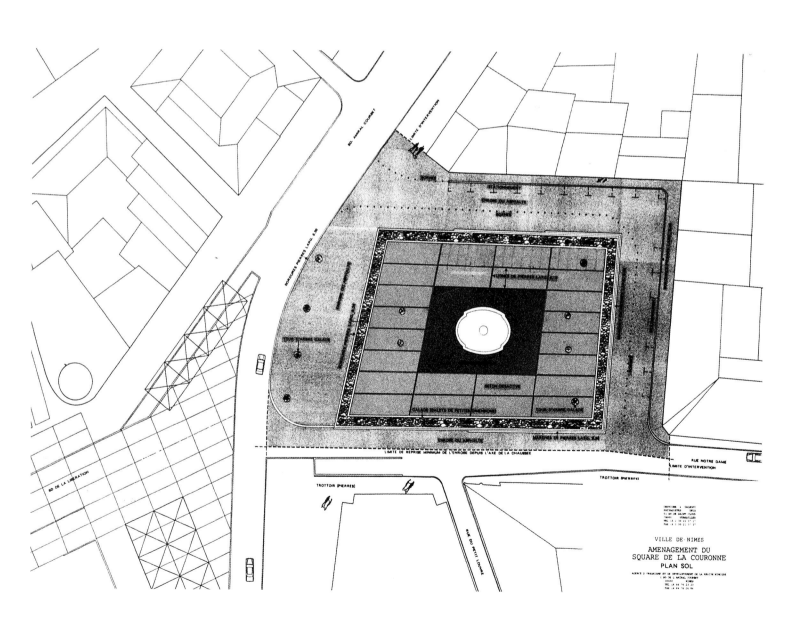

Aerial view (opposite top).
Site plan (opposite bottom).

Views of the square (right and below). Handrails and linear paving treatments mark the boundaries of the square; stone steps bridge the different levels.

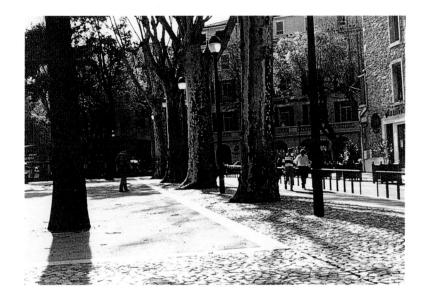

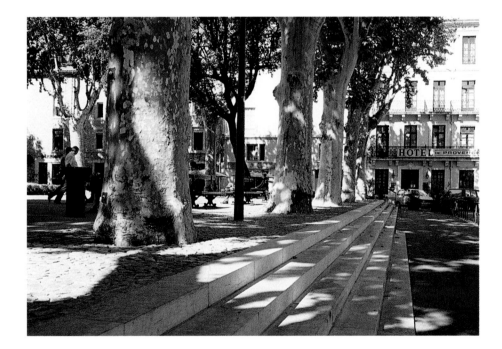

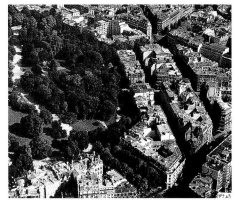

Parc Monceau, a reference point for the project (above).
Plan of the garden in its original version (below left). Plan of the "large garden" version (below center). Plan showing the garden and the landscaped cul-de-sac *villas* (below right).

Plan version in which the garden occupies all of the available area (opposite).

A system of public spaces for the T1-Seine Rive Gauche Quarter, Paris. The original design of the public areas in the T1 quarter of the XIII arrondissement included a small garden (34,432 sq ft) within a larger public space (189,376 sq ft) divided into vehicular and pedestrian routes, squares, and gardens. The project, based on an alternative landscape concept reflecting the example of Paris's Parc Monceau, has the garden occupy all of the central space; the routes connecting it to the adjacent streets are transformed into *villas,* residential streets with dead ends closed by gates that filter off automobile traffic and maintain a level of tranquility within the quarter. Like the Caille garden in Lyon (page 28), this is a hybrid design type that avoids both the indeterminate spatial quality of modern green areas and the rigid discipline of Haussmannian public spaces, while mediating between the two tendencies: the public areas are diversified, hierarchized, and made identifiable, but they have been given a special, completely new character. The design of the garden begins with the superimposition of two plant structures: hedges and stands of trees. Hedges composed of three-feet-high shrubs, pruned flat to recall a labyrinth motif, contain enclosures, pathways, and playgrounds. Various types of trees stand out from the hedges here and there in isolated groups, but do not form a particular geometric arrangement. The intentionally lush vegetation is composed of flowering and fruited plants and shrubs to suggest a lively, domestic image reflecting the cycle of the seasons and evocative of the orchards along the Seine. **144,184 sq ft**

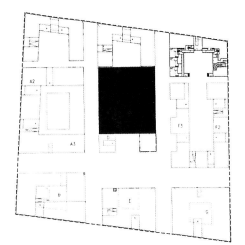

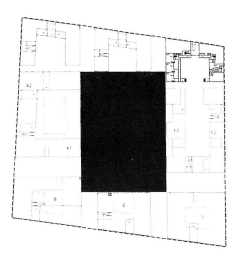

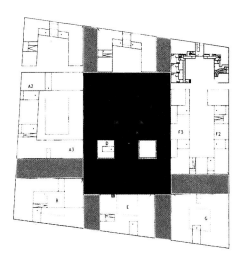

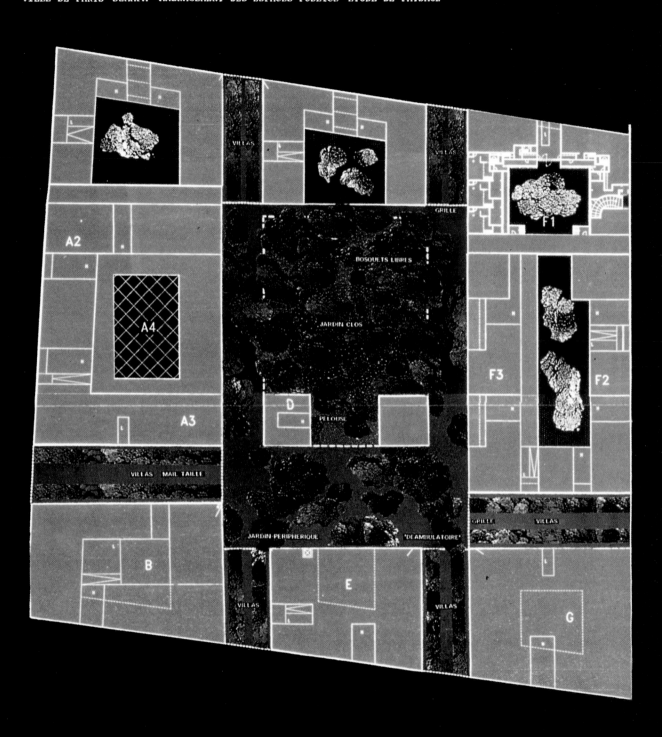

VARIANTE: 'VILLAS & JARDIN'

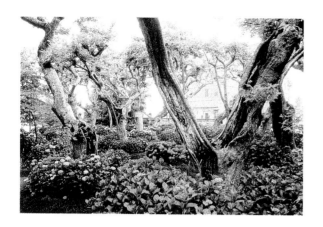

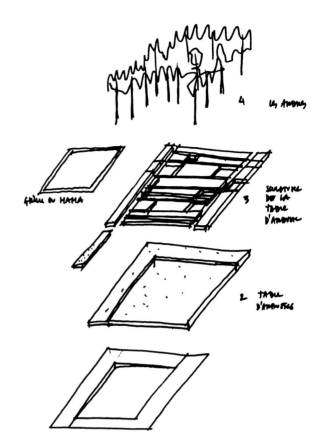

4 LES ARBRES

GRILLE DU HAHA

3 STRUCTURE DE LA TABLE D'ARBORER

2 TABLE D'ARBORER

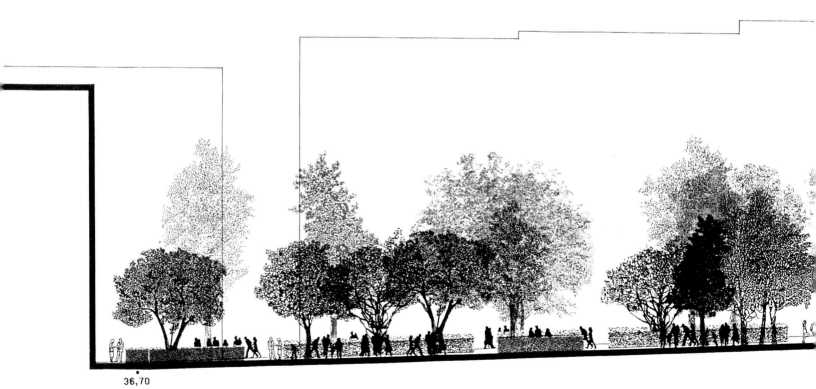

36,70

The garden of Villa Aldobrandini in Frascati, Italy,
served as model for the plant combinations
(opposite left).
Abstract sketches (opposite right): 1. bed.
2. pattern of hedges. 3. topiary-work hedges.
4. trees.
Longitudinal section (bottom).

Blueprints for the plantings (right).

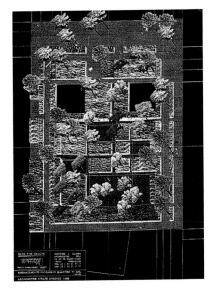

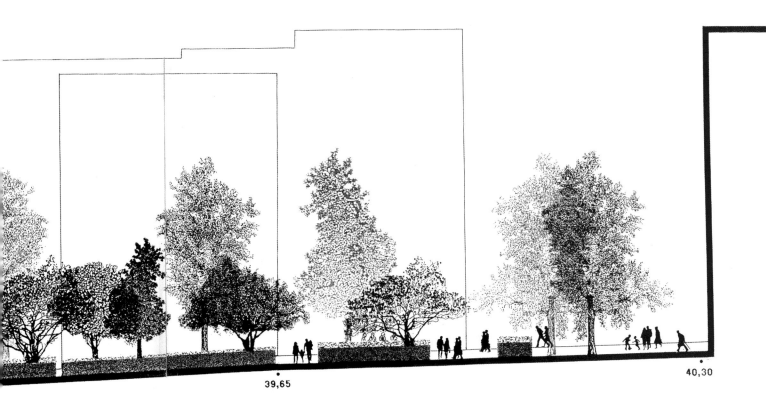

39,65

40,30

Archaeological ruins, an image used as a model in the design of the topiary hedges, one of the principal elements of the garden (opposite).

Site plan documenting various services (right).
Site plan with the various plantings and materials (far right).
Examples of various kinds of pavement (below).

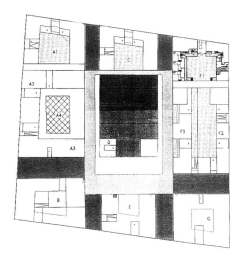

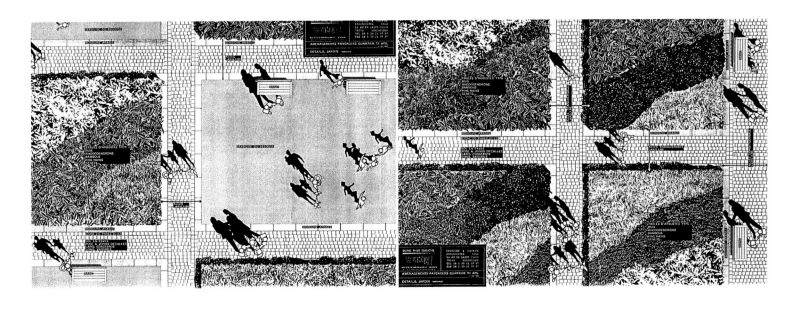

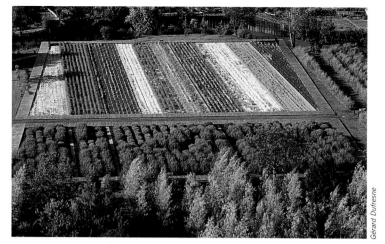

Urban park on the banks of the Théols River, Issoudun. The emblematic starting point of this design is a large, square bed of irises in a terrace over the Théols River, which runs through Issoudun. This explicit reference to French gardens is meant to create a spatial and symbolic connection to the series of urban spaces that contain the city's major monuments (a bell tower, the Tour Blanche, a basilica, a bridge, bastions, and museums). The park's internal design is directly related to the specific site on which it stands, an area just outside the city that has a rustic character: the beds are laid out at slightly oblique angles following the ancient subdivisions of the site into vegetable-garden plots. In keeping with this theme, all sense of decorative fancy has been avoided in the treatment of the rest of the park, which is instead based on the simple metamorphosis of the ancient fabric of small garden plots, which neglect had rendered inextricable. Substitution of the garden vegetation with ornamental plants establishes a transition to the orchards along the banks of the river. The interior paths created in the park and the footbridges spanning the river connect the park to the most distant quarters in the center of Issoudun. The design's restricted budget suggested the adoption of thrifty solutions based on agrarian inspirations, such as the use of a lawn mower to create paths across the broad, flowering field, which is left to grow freely.

247,480 sq ft

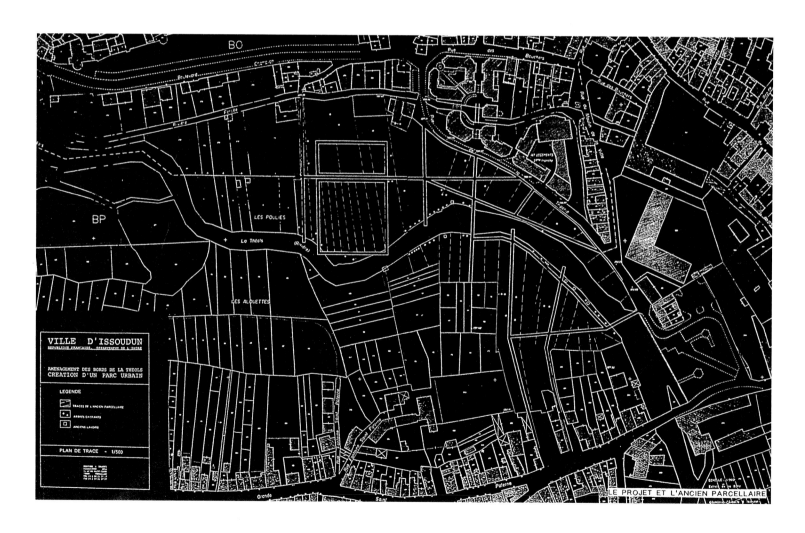

The large bed of irises (opposite top).
Scheme for the plantings, arranged to follow
the ancient parcellation of garden plots (oppo-
site bottom).

The garden in relation to the public spaces that
connect it to various monuments in the city
(right).
Site plan with various plantings (below).

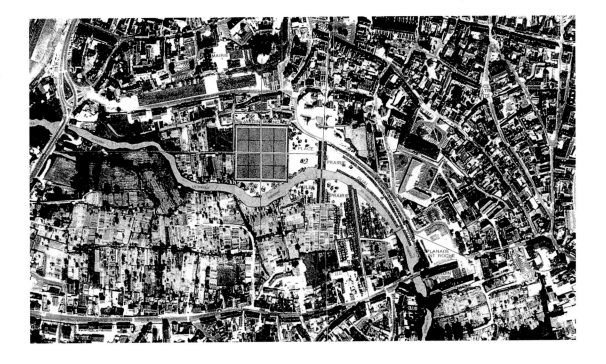

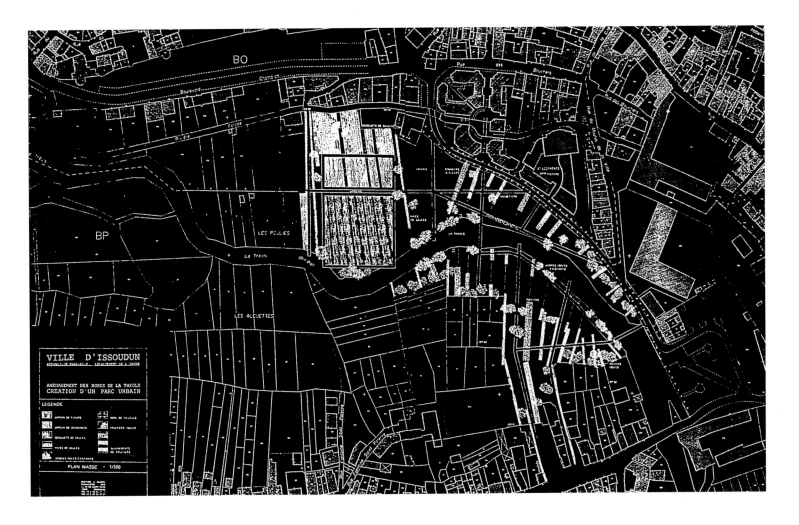

The willow trees and bed of irises in the terrace over-looking the banks of the Théols River (both pages).

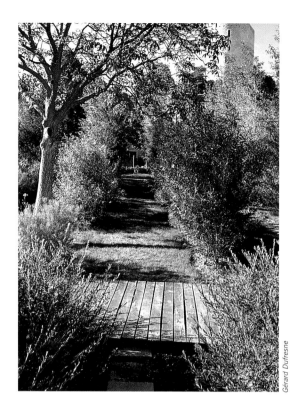

Gérard Dufresne

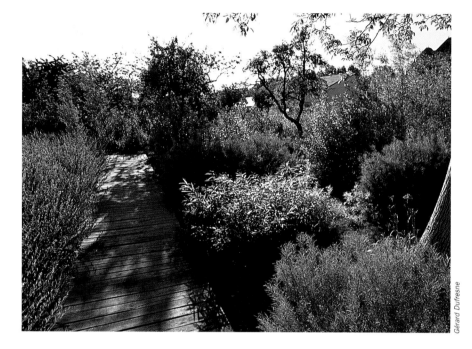

Gérard Dufresne

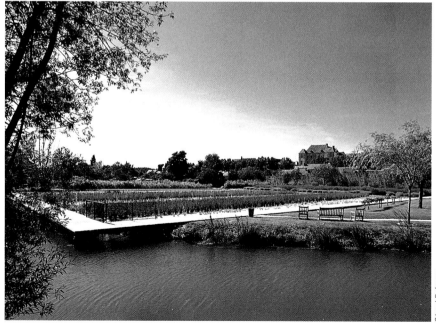

Gérard Dufresne

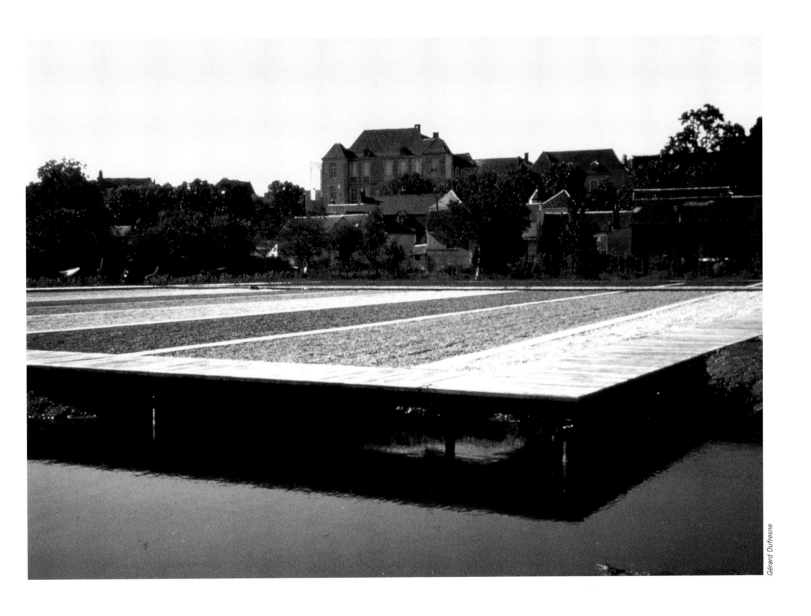

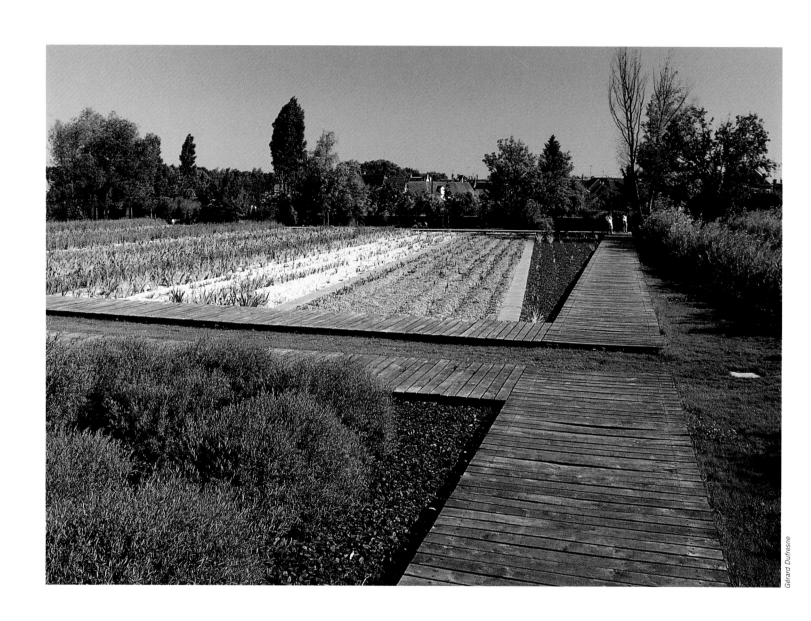

The bed of irises and the garden (both pages).

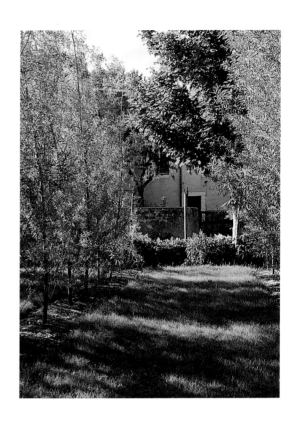

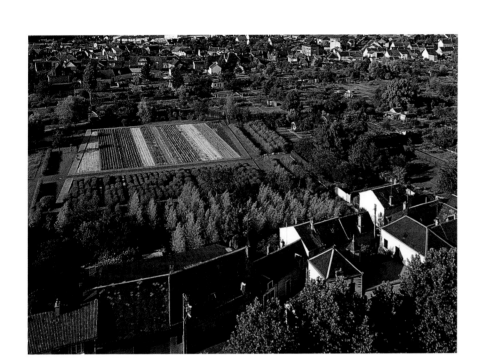

Gérard Dufresne

47

Reworking of the Lustgarten, Berlin. The plan for reworking the Lustgarten — the large public area in front of neoclassical architect Karl Friedrich Schinkel's monumental Altes Museum in the former East Berlin — represents a marked break with traditional treatments of city squares. Berlin's urban spaces have a somewhat fragmented character, evident in the abundance of green spaces. Yet there is a certain continuity of landscape, which the project sought to preserve and improve. Plantings are thus located across the entire surface of the Lustgarten to establish continuity with the surrounding areas. At the center is a "monument garden," crowned by a sacred wood that confers a symbolic character on the site and is in harmony with the many other monuments located in the quarter. **344,320 sq ft**

ALTES MUSEUM

MONUMENT PEDESTAL

EXISTING TREES

CONSERVED FOUNTAIN

ADDITIONAL PLANTING

CATHEDRAL

SACRED WOOD

GARDEN PEDESTAL

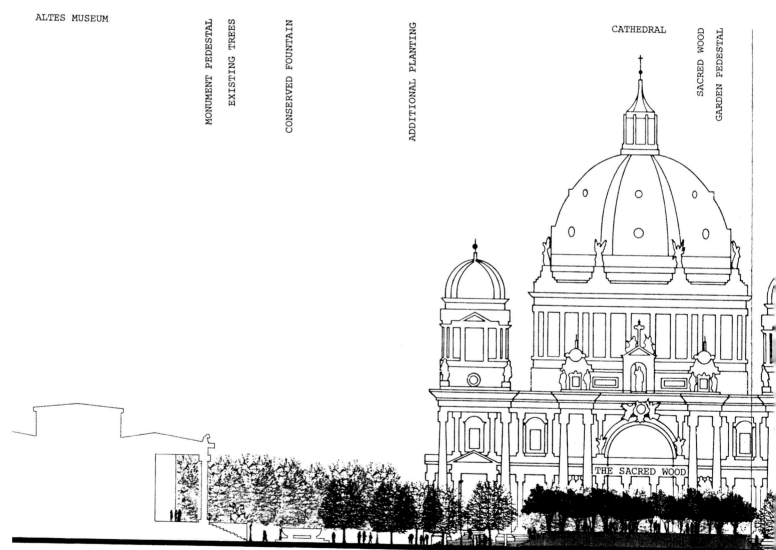

THE SACRED WOOD

SQUARE

ADDITIONAL PLANTING

Aerial view of the Lustgarten (opposite top).
Located in the Museumsinsel, it forms a vast
square bounded by a canal from the Spree, by
the Altes Museum by Karl Friedrich Schinkel,
and by the Domkirche (cathedral).
Longitudinal section (bottom). At far left is the
Altes Museum and, on axis with the Domkirche,
is the "sacred wood" at the top of a monument
garden.

The project provides for the creation of dense
stands of trees in keeping with the character
the city of Berlin (plans, above, left and right).

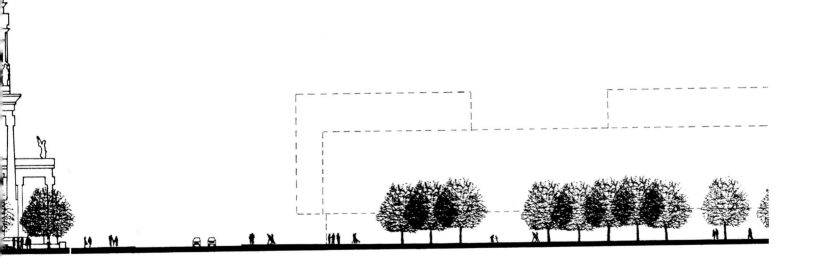

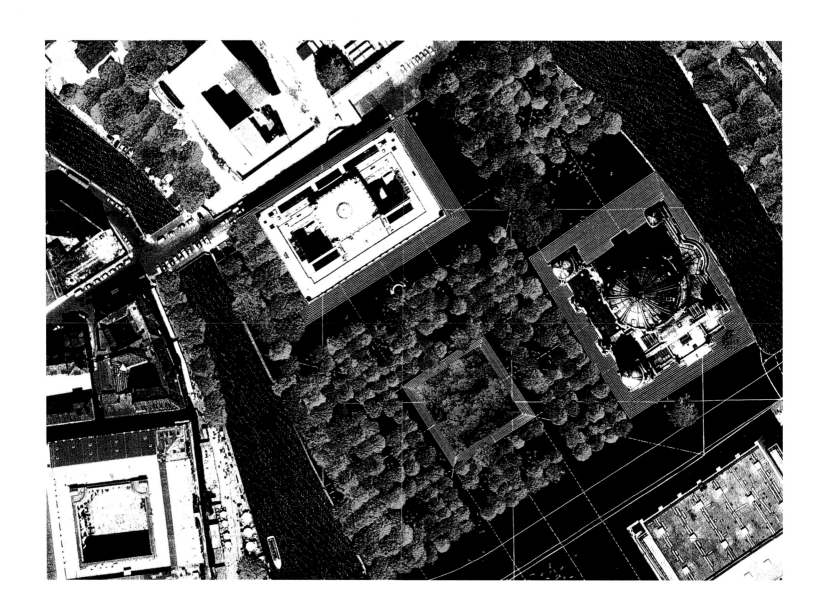

The "sacred wood" (opposite).

Plans for the planting of the trees and various plant species (right and below).

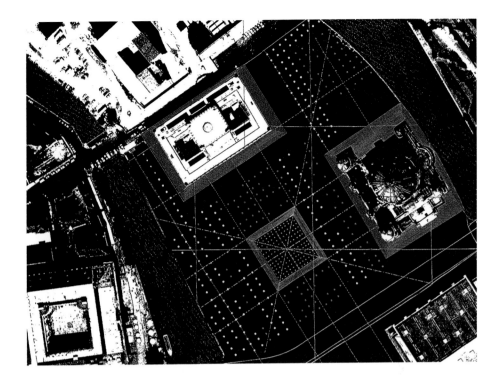

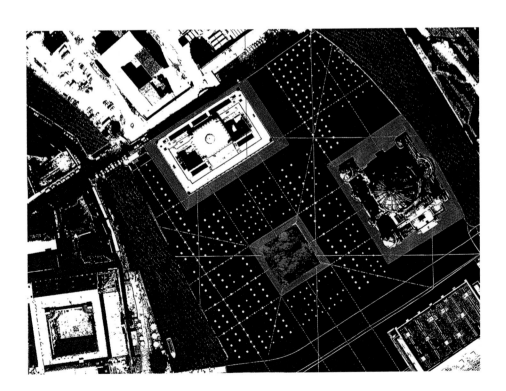

Tourist complex in an abandoned quarry on the bay of Sistiana, Trieste. The design, by Renzo Piano, includes a large hotel complex with docking for pleasure craft. Covering a vast area of about 173 acres, at the northern end of the Adriatic Sea, not far from the border of the Republic of Slovenia, this stretch of coastline

has two nearly contiguous small bays, the first one natural and already provided with a small port, the second one artificial, located on the site of an enormous abandoned quarry that forms a basin with 260-feet-high walls. The base of this second bay is composed of a rocky platform about 33 feet above water level: most of the proposed architecture will be located within this amphitheater. The seaside location suggests two types of landscape interventions: reworking the outline of the coast to provide shelter for the new constructions, and the creation, within the abandoned quarry, of a garden that uses the seaside environment as its primary material. Alluding to the lagoons of Venice and the saltworks of Trieste, this garden will be composed of a series of basins on various levels, arranged to let the tides fill them progressively. At the center of this spiral of tide pools, the last basin will receive fresh water from a spring at the feet of the cliff; aside from washing away the alluvial deposits from the sea, this will help control the salinity of the water in the basins, making it suitable for the kind of flora found in a lagoon environment. **30.6 acres**

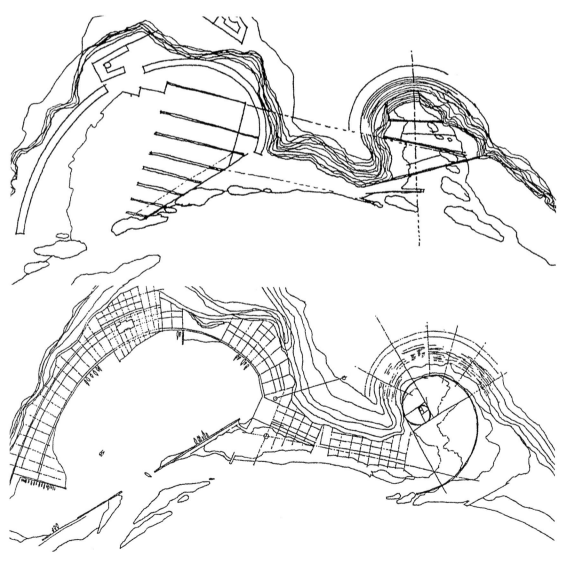

The two bays as seen from the water (opposite top). Sketches of the construction proposed by Renzo Piano: the larger of the two bays is transformed into a small port; the bay formed by the quarry is given a hotel and, in the lower part, a seaside garden (opposite bottom).

The abandoned quarry (below).

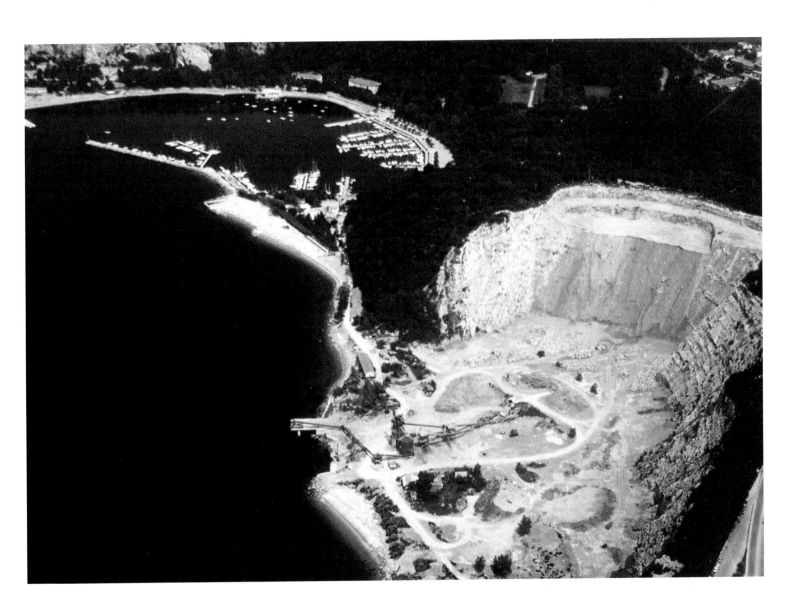

Views of saltworks (below), images that inspired the design of the seaside garden.

Studies for the design of the tidal basins (opposite top). The black areas indicate water. Model of the tidal basins (opposite bottom).

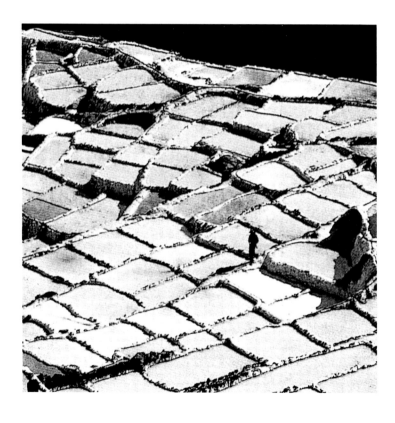

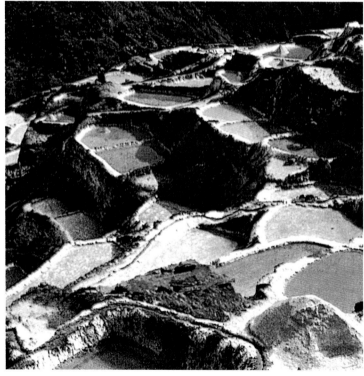

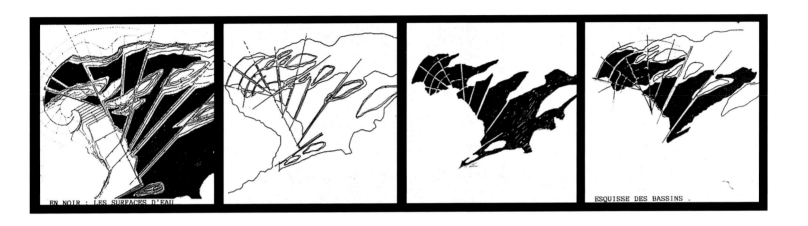

EN NOIR : LES SURFACES D'EAU.

ESQUISSE DES BASSINS.

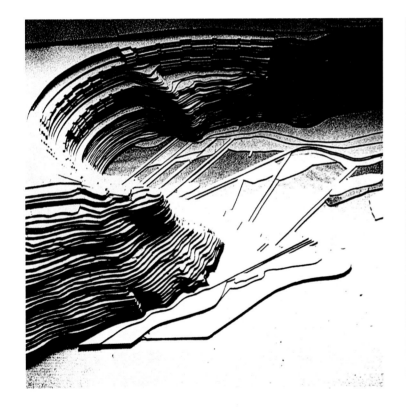

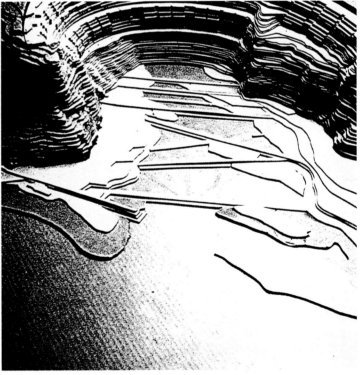

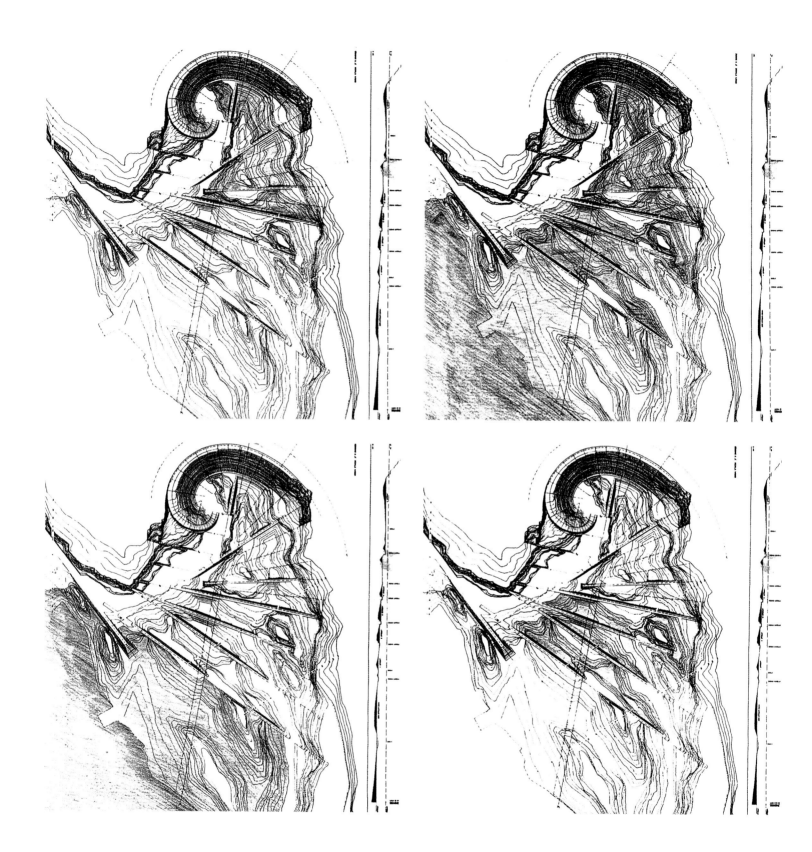

Studies for the design of the tidal basins (opposite and right). The first basin is in direct contact with the sea. The basins further inland are filled by the rising tide. The innermost basin is fed by a freshwater spring located at the feet of the cliff. The landscape is thus in continual flux, governed by the tidal cycle.

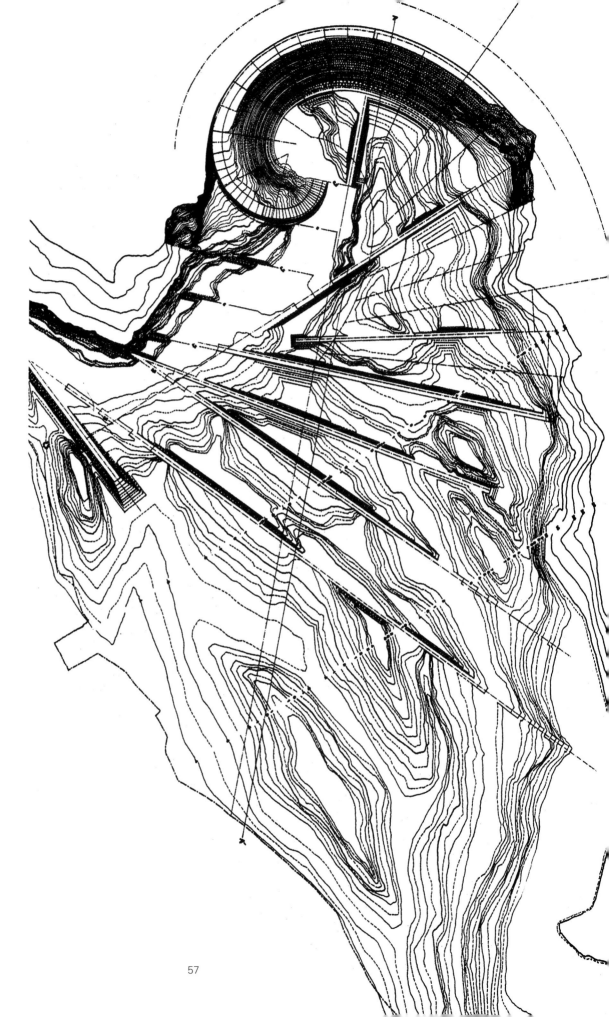

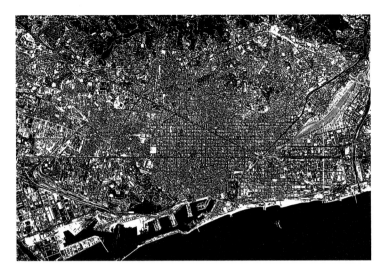

Park for the new quarter adjoining Sagrera train station, Barcelona. The park is a central element in an important project designed by Norman Foster in the center of Barcelona. One side of the park is flanked by the project's new buildings; the other gives on to an expanse of water that roofs over the railway line. The park area, which is shaped like a large, vertical half-moon, is broken up by a series of oblique "barrier walls" that extend the urban grid of Foster's design and thus provide a transition between the city space and the garden. To emphasize this effect, the oblique layout has also been applied to the plantings, which extend from one wall to the next across uneven ground. In contrast to the severity of the walls, Mediterranean landscapes, wild if not desertlike, have been chosen, adding a particular flavor to the overall design.

46 acres

Photomontage of Norman Foster's project for Barcelona (above).
Model of the project (right).

Mediterranean landscapes; such images served as references for the naturalistic parts of the project (opposite).

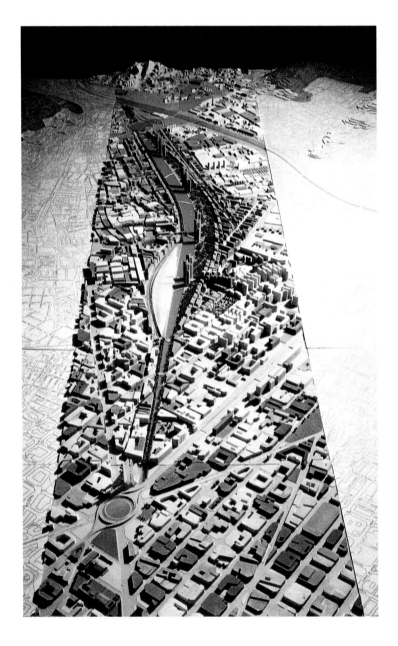

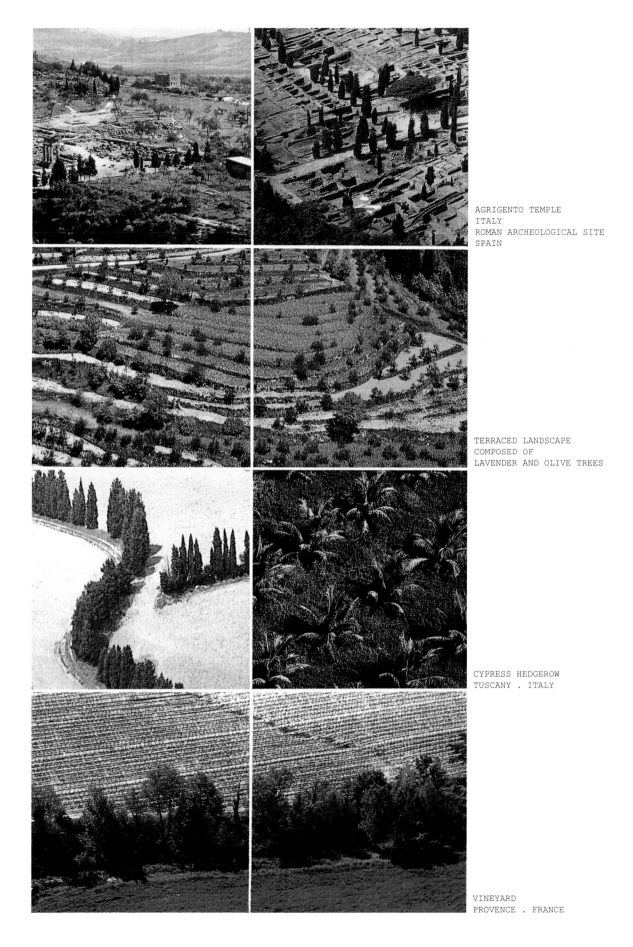

AGRIGENTO TEMPLE
ITALY
ROMAN ARCHEOLOGICAL SITE
SPAIN

TERRACED LANDSCAPE
COMPOSED OF
LAVENDER AND OLIVE TREES

CYPRESS HEDGEROW
TUSCANY . ITALY

VINEYARD
PROVENCE . FRANCE

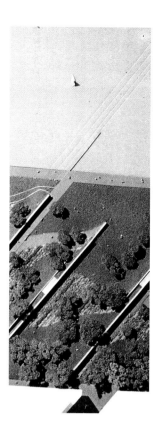

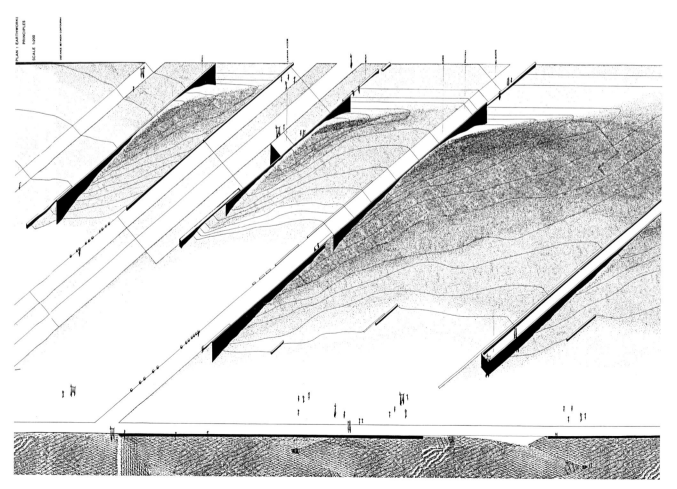

Diagram of the plantings (opposite top left). Arranged to follow the direction of the walls, these plantings create an imperceptible transition between the project's artificial and natural elements.

Model (opposite top center) and axonometric views of the walls (opposite bottom).

The various elements of the park (opposite top left and above, left and right). The urban texture reveals relationships to preexisting geomorphological structures.

Schematic drawings documenting construction phases of the park. 1. Creation of walls that extend the urban grid right up to the canals. 2. Insertion of soil and stones. 3. Planting in fertile ground. 4. Construction of fords that extend the urban grid into the water.

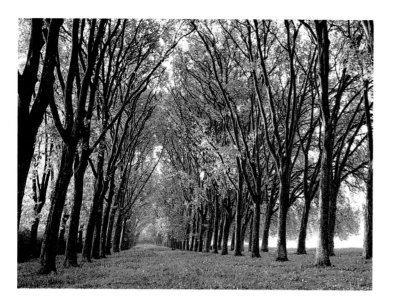

Landscaping for a new TGV Méditerranée Station, Valence. The site of the station of the TGV (train á grande vitesse, or high-speed train) is indicated by two long rows of plane trees that run alongside the tracks for almost 2,000 feet; these are flanked by another two rows of fruit trees. This formation is inspired by the traditional *thése*, the double row of plane trees lining the approach to a Provençal *mas* (country house), and it thus integrates the railroad infrastructure within a traditional visual motif from the landscape of southern France. **49 acres**

A *thése*, the traditional double row of plane trees that marks the approach to a Provençal country home (left).
Plan of the plantings (below) and of the plant structure (opposite).

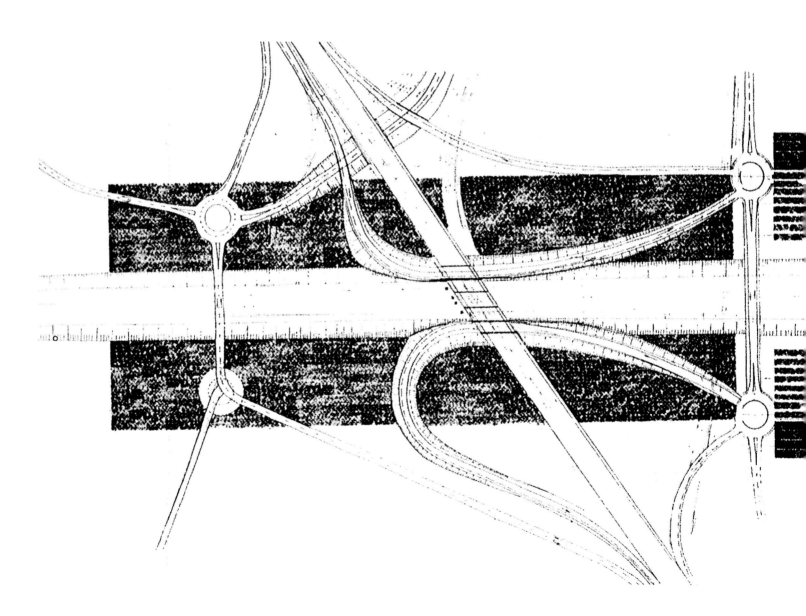

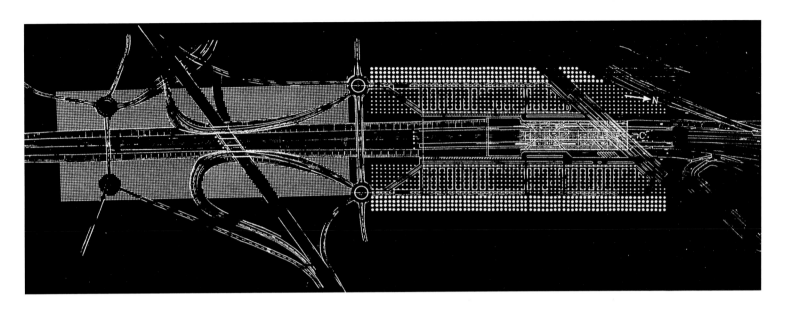

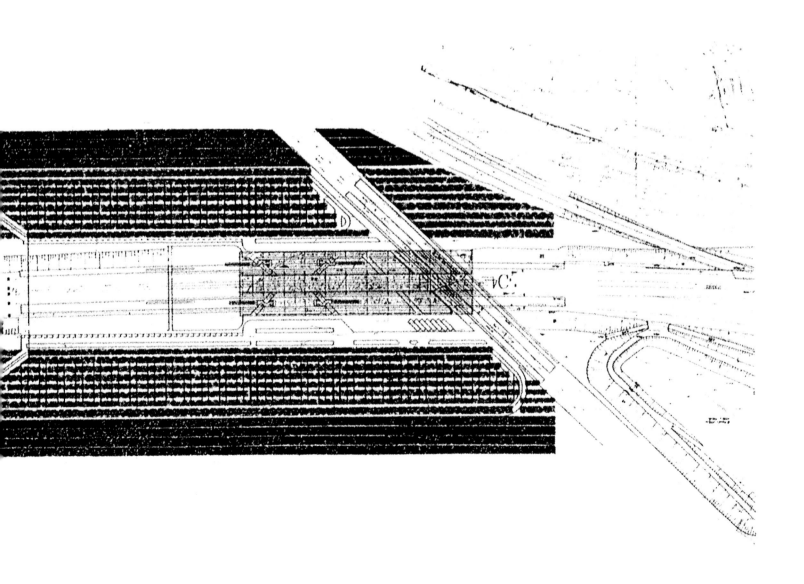

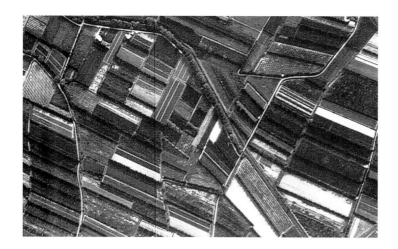

Landscaping for a new TGV Méditerranée Station, Avignon. As with the train station in Valence (page 62), a *thése* of plane trees indicates the presence of the station. The parking lots, protected by rows of lime trees, are designed to imitate the form of nearby orchards, thus reproducing the structure of the landscape in which the station is set. **81.5 acres**

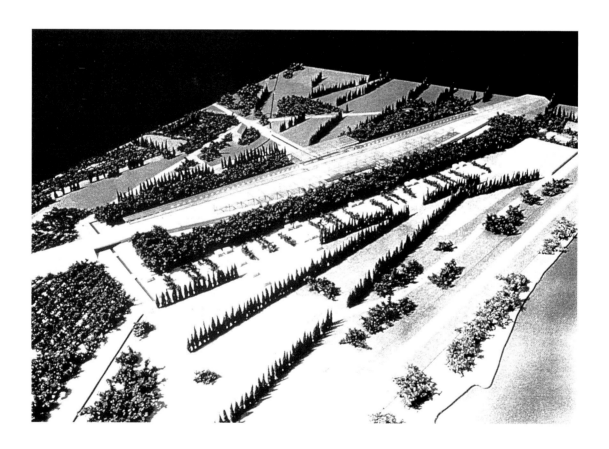

Aerial view of the surrounding area (opposite top). Model of the station (opposite bottom). The *thèse* of plane trees gives the station a regional identity.

The station is surrounded by orchards protected by rows of lime trees, and this basic pattern is faithfully reproduced in the design of the parking lots (below).

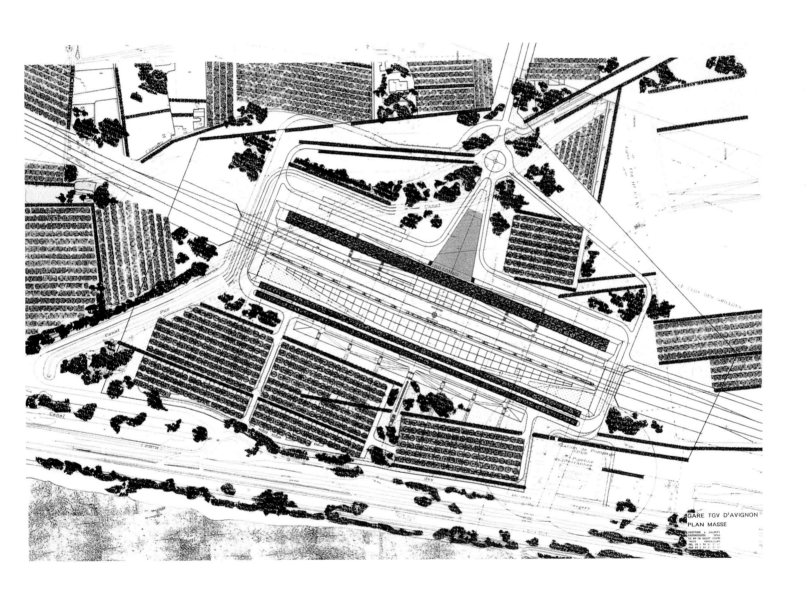

GARE TGV D'AVIGNON
PLAN MASSE

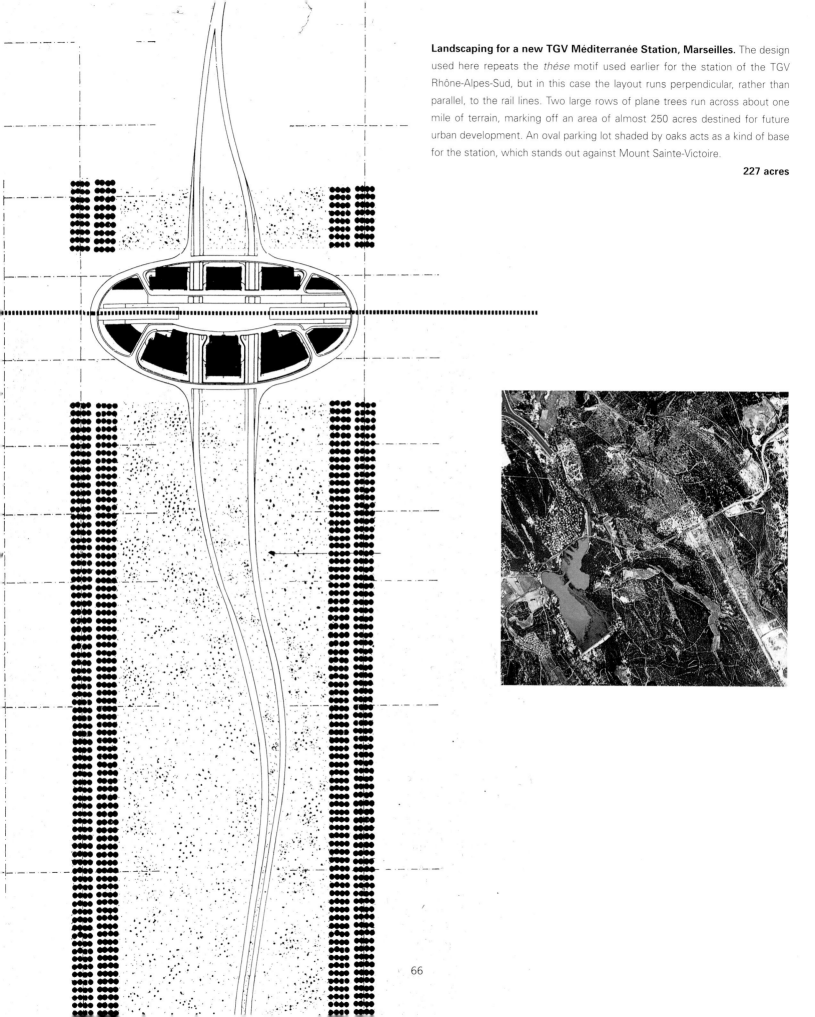

Landscaping for a new TGV Méditerranée Station, Marseilles. The design used here repeats the *thése* motif used earlier for the station of the TGV Rhône-Alpes-Sud, but in this case the layout runs perpendicular, rather than parallel, to the rail lines. Two large rows of plane trees run across about one mile of terrain, marking off an area of almost 250 acres destined for future urban development. An oval parking lot shaded by oaks acts as a kind of base for the station, which stands out against Mount Sainte-Victoire.

227 acres

The regional motif of double rows of plane trees, used in this case perpendicularly to the station, embraces a large area that may serve as the center of urban expansion (opposite left). Aerial view of the site (opposite right).

The orderly rows of trees protect the parking areas from the intense summer sun (below).

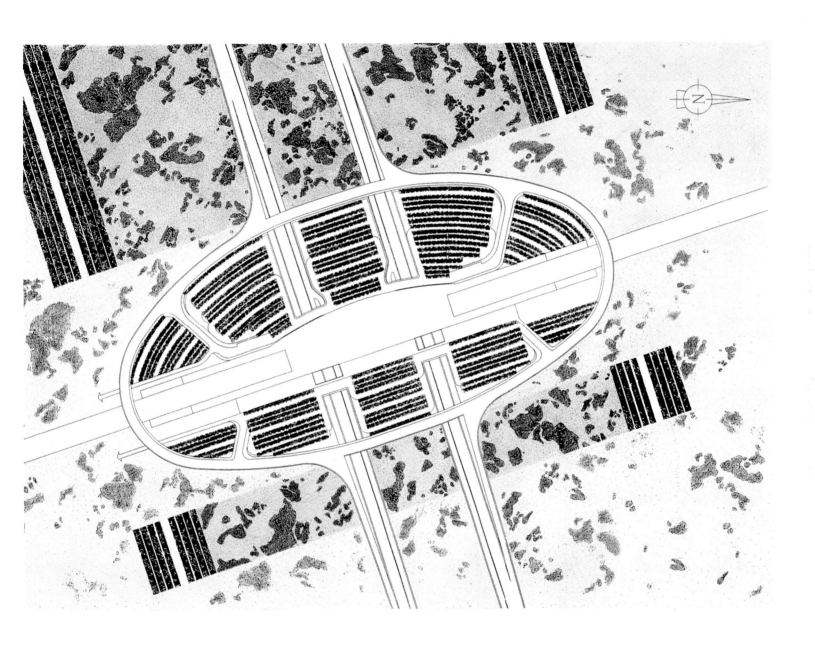

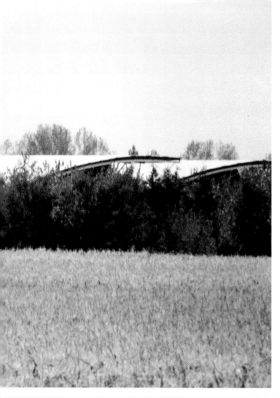

Landscaping and parking areas for the Thomson Factory, Guyancourt. This project served two objectives: on one hand, the short-term creation of a landscape setting for the Thomson Factory designed by Renzo Piano; on the other, the formulation of a longer-term vision of the site, providing for its possible reuse, if, for example, the factory were to close. The short-term project began with a preliminary analysis of the drainage problems presented by run-off waste water, since the factory was not yet connected to the city sewer system. Thus, even before work began on the foundation for the building designed by Renzo Piano, a collecting trough and network of canals had to be created. These canals were left open on top and later served to irrigate the rows of willows that delineate the geometric outline of the parking area. The bands of cement between one canal and the next are slightly convex so that while permitting cars to circulate and park they also permit the run-off of excess water, which, after being passed through a hydrocarbon separator, is then moved on to the collecting trough. The first stage of the landscaping was supplied by plantings in which the willows were flanked by stands of rapid-growth poplars. The longer-term project was based on a broad analysis of the landscape on the plain of Saint-Quentin. The original plantings have lifespans of only a few decades, periods that correspond to the lifespan of the average industrial park; black pines were then slowly added to these plantings, and at an even slower rate more noble species will be added, such as beeches and oaks. Such trees, destined to live several centuries, will take their place in the long-term configuration of the landscape of the plain of Saint-Quentin. **57 acres**

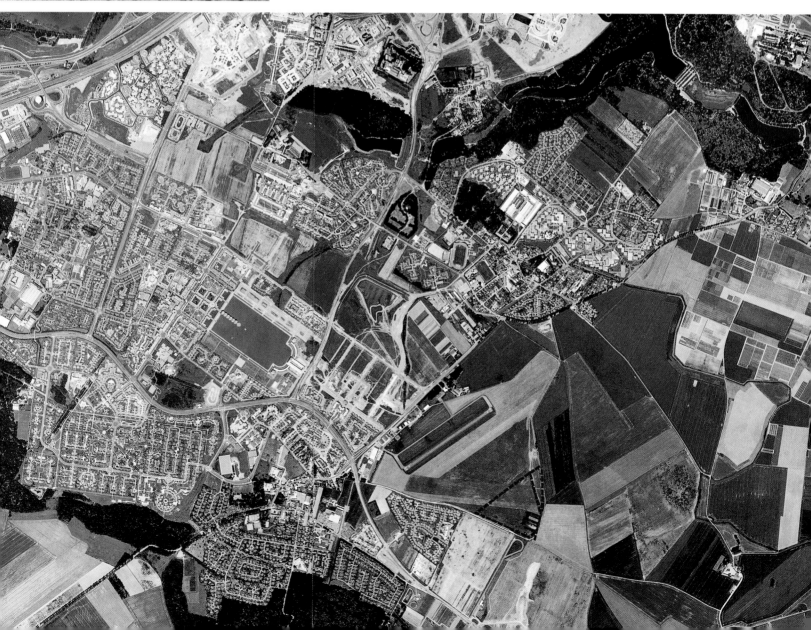

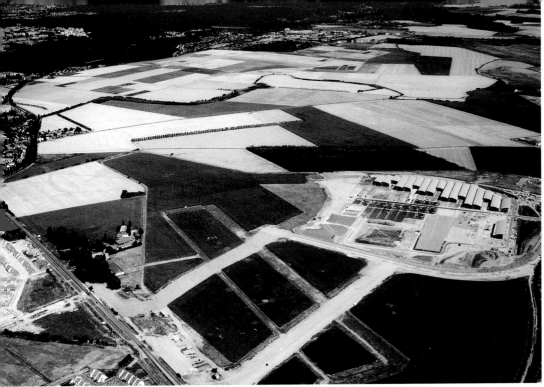

The factory as seen from a nearby field (opposite top). Aerial view of the plain of Saint-Quentin showing the patchwork of agricultural fields progressively being taken over by the advance of industrial installations (opposite bottom).

Views of the Thomson Factory designed by Renzo Piano (left and below).

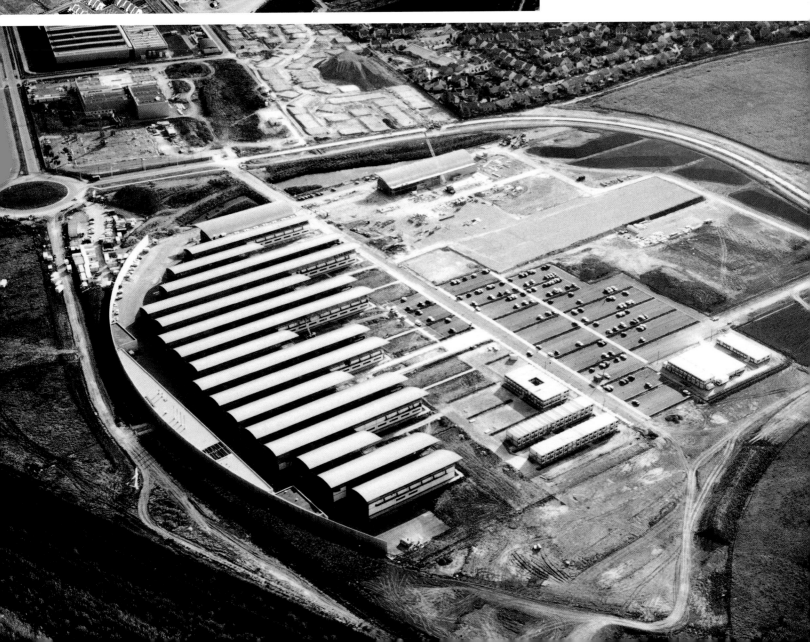

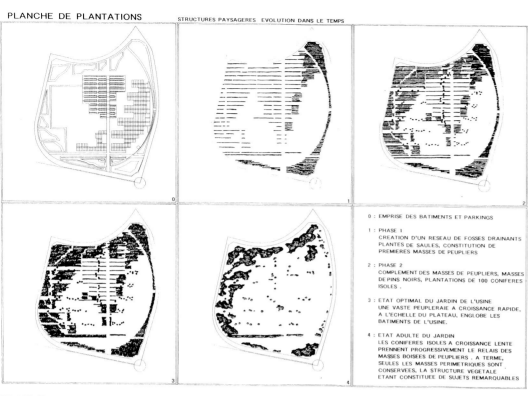

0 : EMPRISE DES BATIMENTS ET PARKINGS

1 : PHASE 1
CREATION D'UN RESEAU DE FOSSES DRAINANTS
PLANTES DE SAULES, CONSTITUTION DE
PREMIERES MASSES DE PEUPLIERS

2 : PHASE 2
COMPLEMENT DES MASSES DE PEUPLIERS, MASSES
DE PINS NOIRS, PLANTATIONS DE 100 CONIFERES
ISOLES .

3 : ETAT OPTIMAL DU JARDIN DE L'USINE
UNE VASTE PEUPLERAIE A CROISSANCE RAPIDE,
A L'ECHELLE DU PLATEAU, ENGLOBE LES
BATIMENTS DE L'USINE.

4 : ETAT ADULTE DU JARDIN
LES CONIFERES ISOLES A CROISSANCE LENTE
PRENNENT PROGRESSIVEMENT LE RELAIS DES
MASSES BOISEES DE PEUPLIERS . A TERME,
SEULES LES MASSES PERIMETRIQUES SONT
CONSERVEES, LA STRUCTURE VEGETALE
ETANT CONSTITUEE DE SUJETS REMARQUABLES

Diagrams showing the phased plantings (left).
Phase 0: The area of the architectural interven-
tion. Phase 1: Creation of a network of drainage
canals planted with willow trees to be flanked
by the first groups of poplars. Phase 2:
Completion of the poplar groves, placement of
black-pine stands and 100 isolated conifers.
Phase 3: Optimum state of the factory's garden.
A large grove of fast-growth poplars at the level
of the plain surrounds the industrial buildings.
Phase 4: Mature stage of the garden. The isolat-
ed conifers, slow-growing, gradually replace the
poplars until only the rows along the outside
perimeter will remain. This new vegetation of
impressive trees will become an enduring
aspect of the landscape of Saint-Quentin.

The garden (below), and parking area after the
insertion of the willows (opposite top).

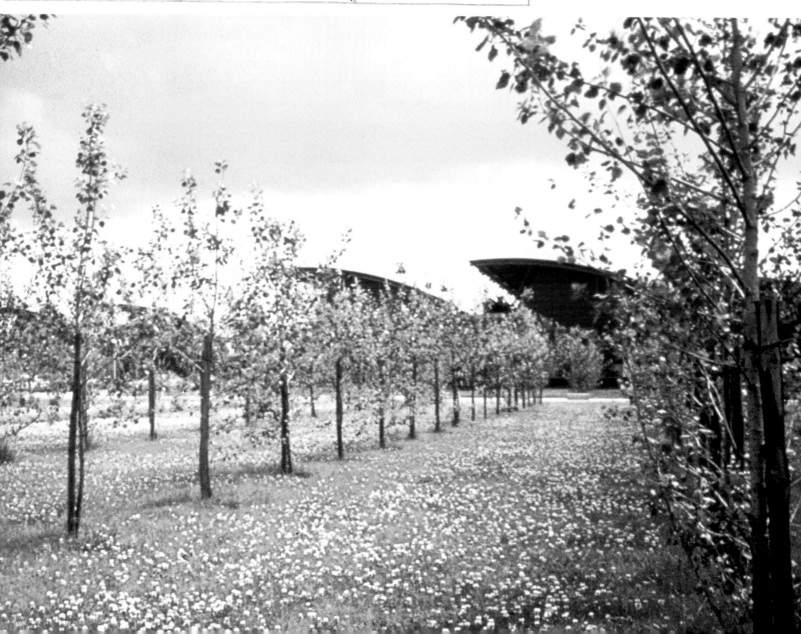

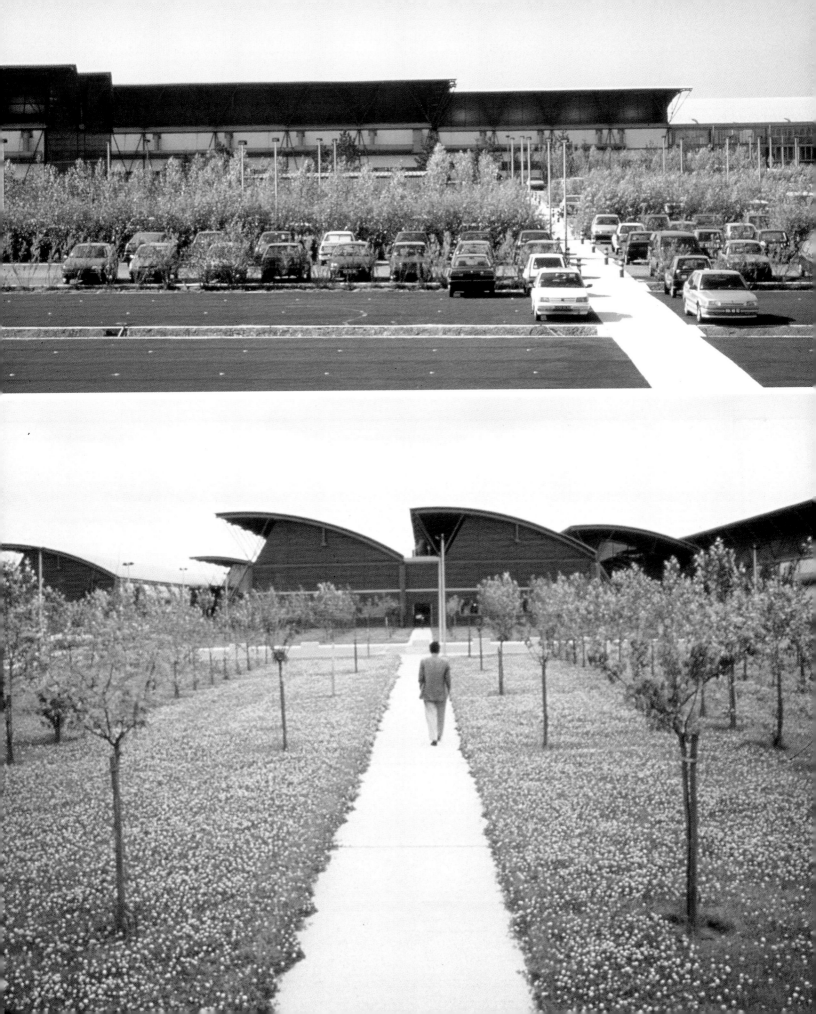

Plan of parallel drainage canals arrayed across the parking area (right). Run-off water is directed toward a collection trough at the far end of the installation.
The drainage canals as they appeared before the willows were planted (below).

Cross section through drainage canal with a young willow (opposite top).
View of the parking lot (opposite bottom).

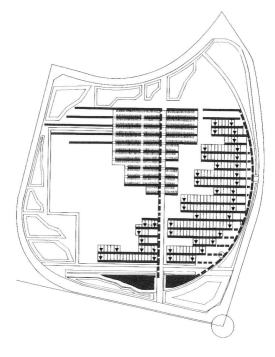

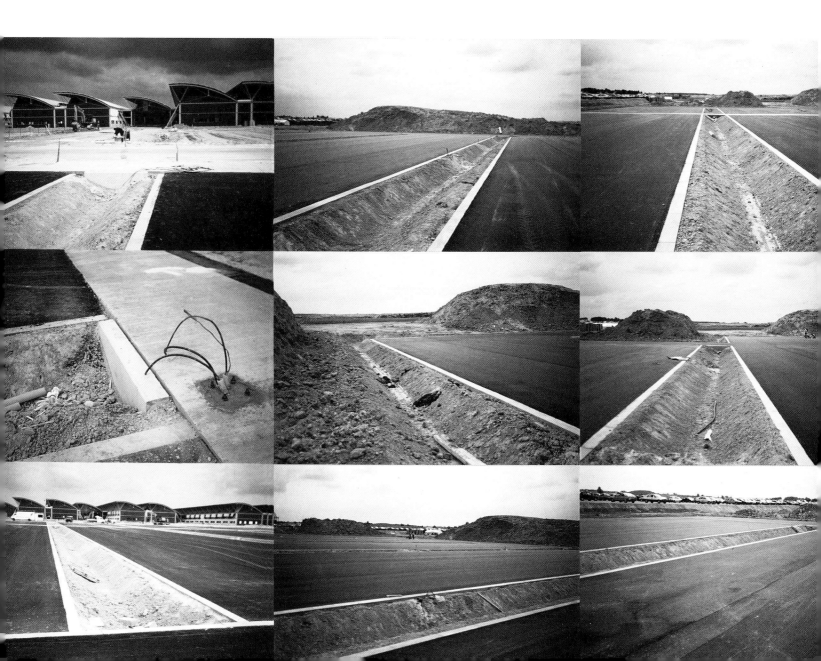

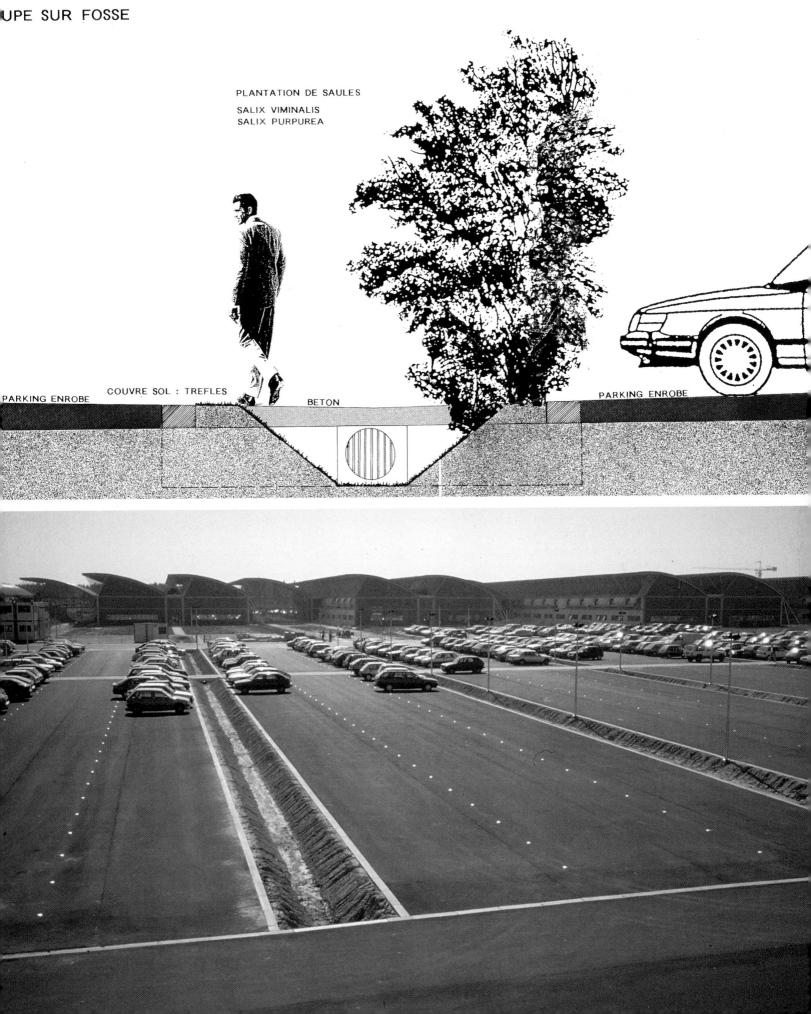

PLANTATION DE SAULES
SALIX VIMINALIS
SALIX PURPUREA

COUVRE SOL : TREFLES

PARKING ENROBE

BETON

PARKING ENROBE

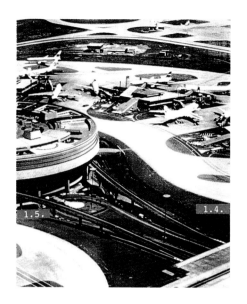

1.5. 1.4.

Access-road treatments for Roissy-Charles de Gaulle Airport. The project was based on the idea of making use of the abstract monumentality of the landscape and architecture of Roissy-Charles de Gaulle Airport, rather than attempting in some way to falsely "humanize" it. The project was directed at four sites: the grounds of the three air terminals (CGD1, CDG2, CDG3); their access roads and, for CDG2 and CDG3, their exterior parking areas; the route of a new automatic "internal door-to-door" delivery system, a kind of mini-subway connecting the three air terminals; and, finally, the grounds of a future highway connection to the east. The airport's internal-circulation infrastructure, located at a lower level than the runways, forms a large, man-made valley. The aim of the project was to increase the "legibility" of this valley. To that end, the existing plantings on the slopes, limited primarily to grassy expanses with occasional plantings, were replaced by a double layer of plants of a more structural nature. The first of these layers was composed of highly homogeneous shrubs set along the lines of the curves of the slopes. These serve the purpose of increasing visual perception of the contrast between the horizontal plane of the runways and the enclosed areas of the access routes. The second layer was composed of groups of trees typical of the region of Ile-de-France, chosen in part for their misleading sizes, which increase the sense of the absence of a precise scale that is characteristic of the site.

61 acres

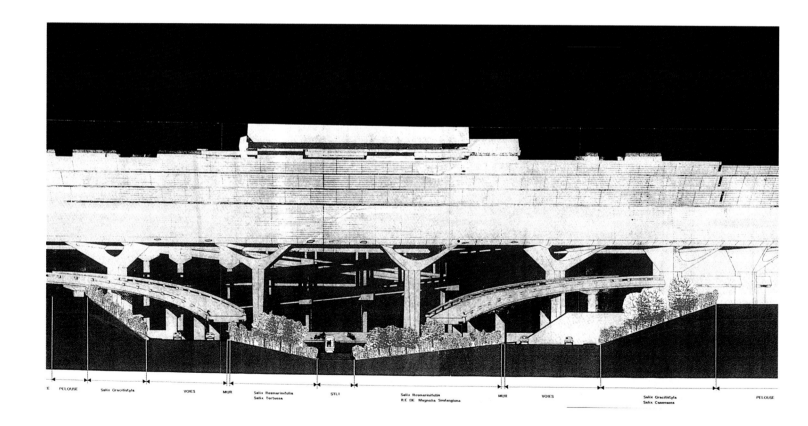

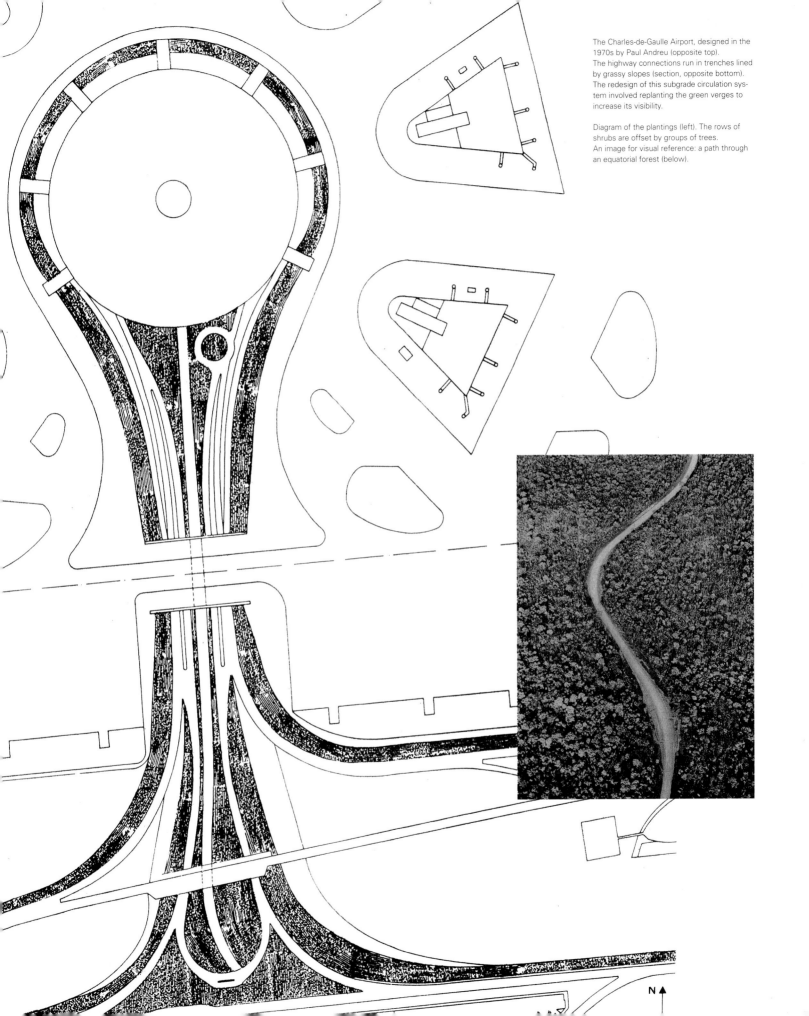

The Charles-de-Gaulle Airport, designed in the
1970s by Paul Andreu (opposite top).
The highway connections run in trenches lined
by grassy slopes (section, opposite bottom).
The redesign of this subgrade circulation sys-
tem involved replanting the green verges to
increase its visibility.

Diagram of the plantings (left). The rows of
shrubs are offset by groups of trees.
An image for visual reference: a path through
an equatorial forest (below).

N ↑

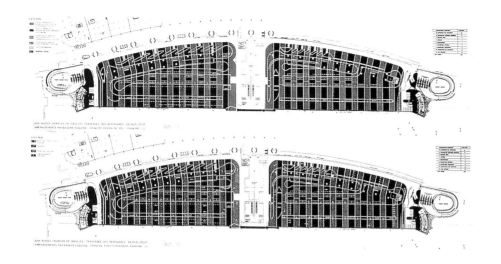

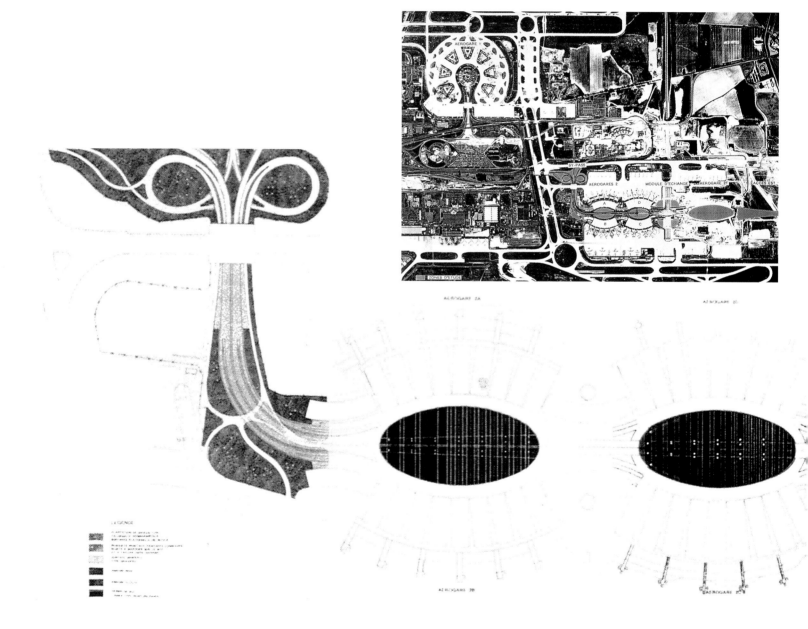

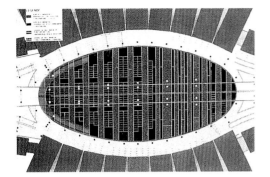

Diagrams of the parking lots and paving schemes for terminals CDG 2 and CDG 3 (opposite top, and near left).
Aerial view of Charles-de-Gaulle Airport (opposite center). Air terminal CDG 1 is at upper left, CDG 2 and CDG 3 are at lower right.
Unlike the architecture of CDG 1, terminals CDG 2 and CDG 3, also designed by Paul Andreu, follow a "centrifugal" model: a connecting highway runs among the various elements, which are located in a ring around parking areas (opposite bottom).

Studies for the pavement (below). To increase the visibility of the markings, the white lines are larger than the norm used for regular roads. Two different pavement patterns, black and "striped," are used to distinguish transit zones from zones were stopping is permitted.

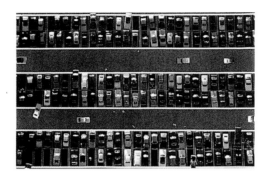

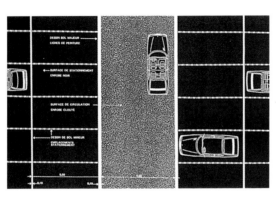

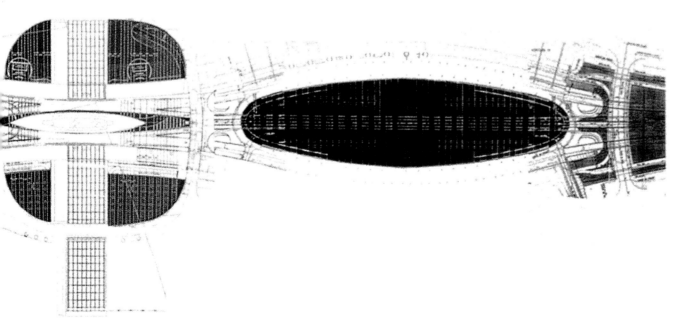

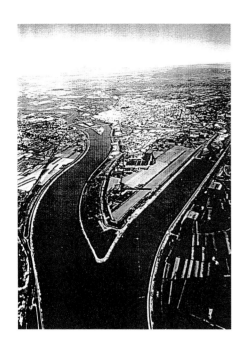

Landscaping along rail viaducts over the Rhône River at Avignon. Contrary to popular opinion, which holds that the installation of any infrastructural element must automatically damage the environment, this project was designed to have a positive impact by serving as the impetus behind the renovation of a landscape. The project was based on two distinct levels: first, the structural and architectural definition of the viaduct itself; second, turning all of the infrastructural/landscape effects of the project into instruments for renovating this section of the Rhône valley. Regardless of any polemical aesthetics, the design of the architecture of a viaduct is an application of conceptual and ideological economy in technical thought: the use of a minimum of materials (in this case reinforced concrete) to overcome with a maximum of regularity differences in heights on a landscape. The work done on the landscape begins with an examination carried out to isolate and identify the landscape's various "languages," which will serve as the matrix of the renovation. Three areas were identified (and thus three "languages"). First was that of the Massif des Angles, from which the viaduct opens, which is covered by garigue crisscrossed by a pattern of ancient ancestral paths. Second was the landscape with farm plots extending outward from both banks of the river. This area is characterized by cypress hedgerows located on the borders of the agricultural holdings. Finally, there were the banks of the river itself, which are home to wild vegetation broken by stands of willows and poplars. The treatment of the landscape was intended to accentuate and improve these existing qualities. In addition, a retaining basin for the water that runs off the tracks of the TGV (high-speed train) permits the creation, at the top of the Massif des Angles, of a broad terrace overlooking a panoramic view of the landscape. **81.5 acres**

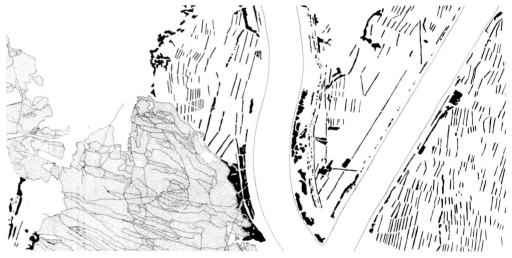

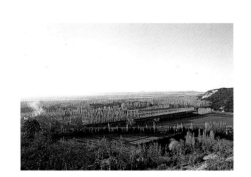

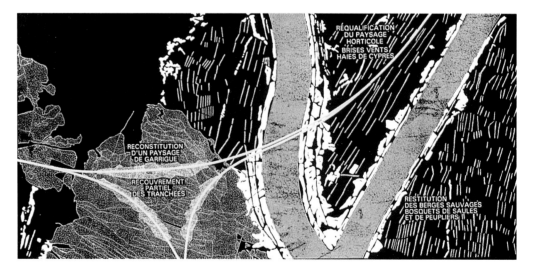

The plain of La Courtine, at the confluence of the Durance and Rhône rivers, with the city of Avignon to the north (opposite top).

View of the western bank of the Rhône (opposite center left). To the right is the Massif des Angles; in the foreground are some of the agricultural fields characteristic of the plain of La Courtine.

Figure-ground map showing the three preexisting "languages" (opposite center right). First is the indigenous vegetation of the Massif des Angles, crisscrossed by a thick pattern of ancestral paths. Next is the wild growth along the riverbanks. And last is the area of cultivated fields broken by linear stands of trees and hedgerows that serve as windbreaks.

The future route of the speed train runs across a landscape that has been redesigned on the basis of its different existing "languages" (opposite bottom).

Cross section and plan of the double viaduct, an optimized expression of the highway aesthetic (right).

Models of the viaduct (below).

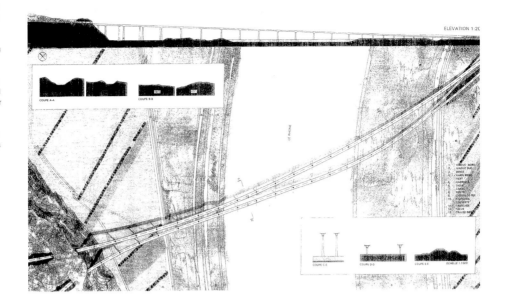

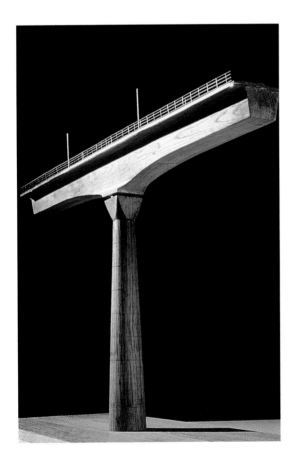

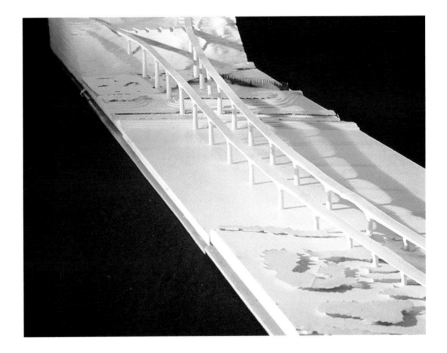

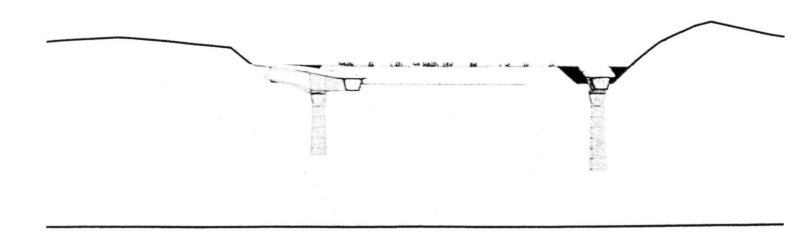

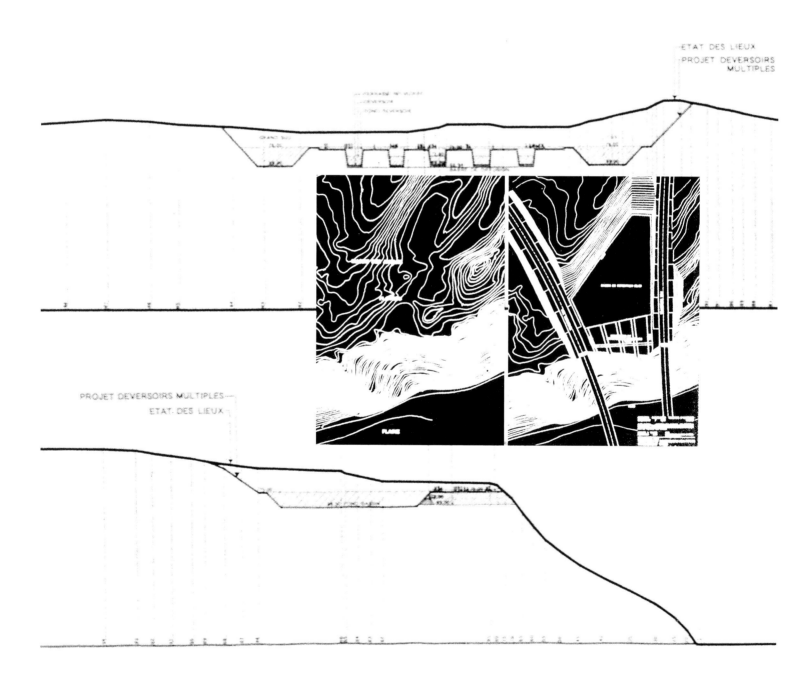

Cross section of double viaduct near the water-collection basin (opposite top). Cross-section of the underground elements (opposite center). Perpendicular section with the terraces built along the edge of the ridge between one underground element and the next (opposite bottom). Map of the plantings in their current state and map indicating eventual arrangement (inset, opposite).

Map of the area involved (right). The basin for water collection is located on the edge of the Massif des Angles at the point where the double viaduct crosses the valley of the Rhône. Perspective view of the opposite bank (below). The terrace between the two viaducts is outlined by large pine trees.

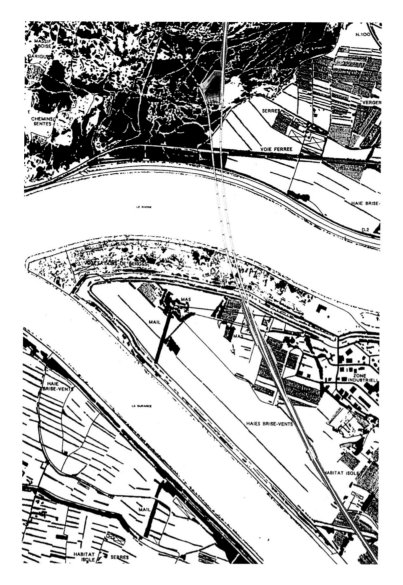

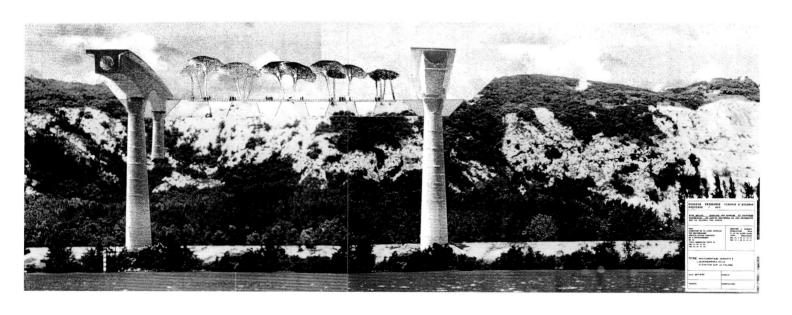

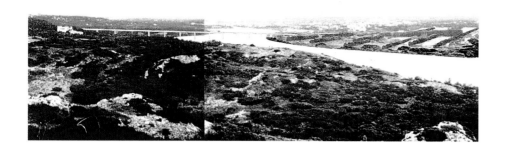

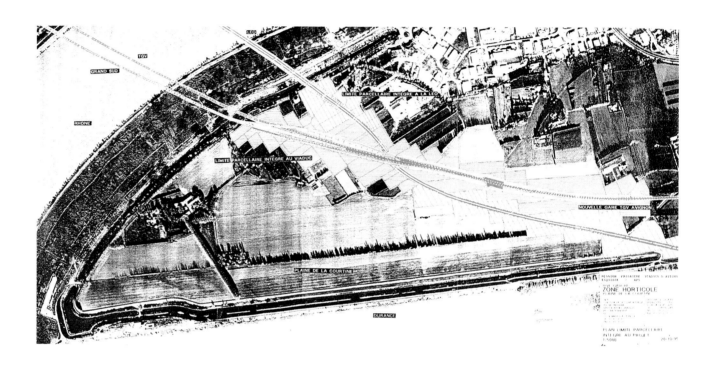

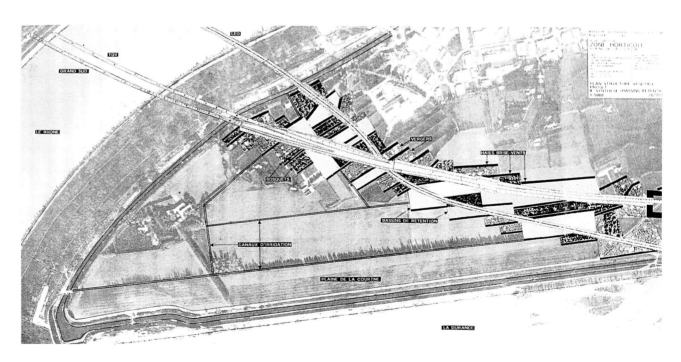

View of the outlets of the viaducts on the La Courtine Plain at an altitude of about twenty meters (opposite top). To avoid having to build giant embankments, the viaducts have been extended about five hundred meters (1,600 feet). The project proposes applying the landscaping to the areas on both sides of the route of the viaduct along most of its length (opposite center). In keeping with the "language" of the region, the rows of trees and hedges that serve as windbreaks for the small farm plots are renovated. Some of these are transformed into basins for collecting run-off water from the area crossed by the speed train (opposite bottom).

Map of the hedgerows that mark off the farming plots on the site (right).
The plain of La Courtine with the viaducts and the windbreaking hedgerows (below).

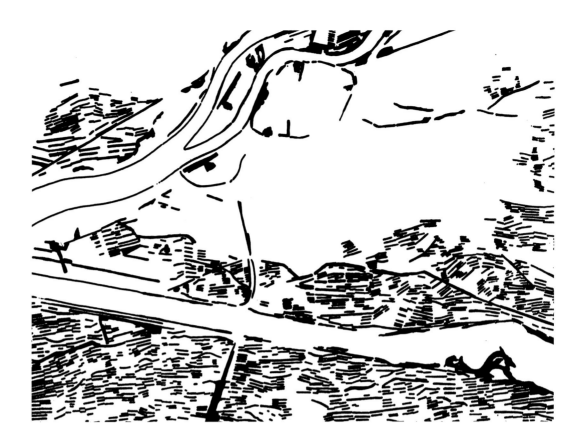

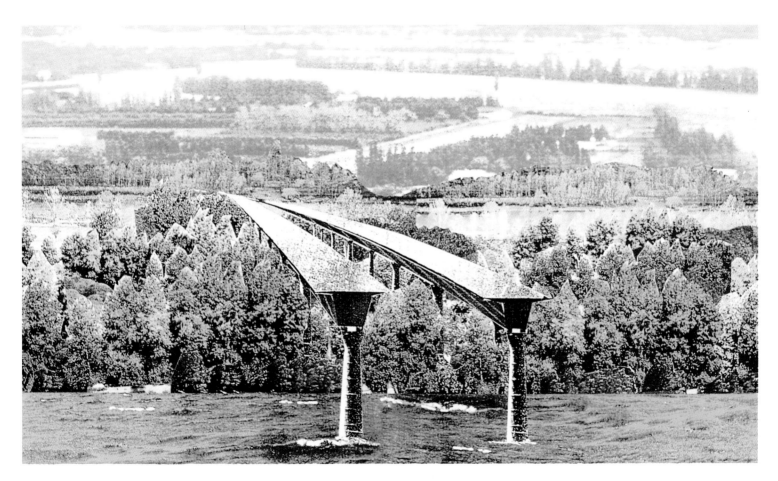

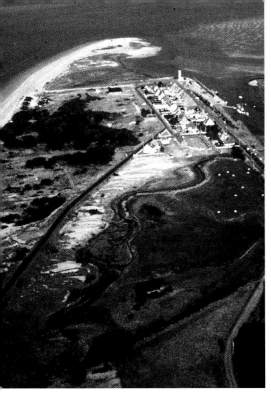

Study of the future of Pointe du Hourdel, Cayeux-sur-Mer. The opportunity to suggest works for a landscape that is at the same time wild and inhabited, natural and artificial, offers the chance to turn a project into a true "landscape manifesto." The basic theme of the project is the systematic improvement of existing forms or their reinterpretation to meet new needs. The project is based on the identification of four "themes" (elements of the landscape or infrastructure) that need to be adapted to serve their probable evolution; those areas of the landscape that have no need of this are not taken into consideration. To the north is an area of rocky banks with a quarry: the project proposes renovating the area in a way that gives equal respect to the landscape and to the mechanical and industrial patrimony tied to its exploitation; the principal stages consist of an adequate renovation of the machinery and the transformation of sunken areas into bodies of water. To the east, the small pleasure-craft harbor will be enlarged to accommodate an inevitable increase in tourism. The project thus involves the reproposal of "hunting ponds," a natural type of small hunting preserve accessible to the tides and inhabited by certain plants. To the south, the geometric shapes of the small farming plots would be reworked, in particular through reconstruction of embankments and enclosure canals. The large influx of visitors during the summer season suggests the transformation of some holdings into parking spaces. Finally, in order to increase the port's housing facilities, the project includes the use of a type inspired by a Norwegian model: wooden houses aligned along dike-embankments. **988 acres**

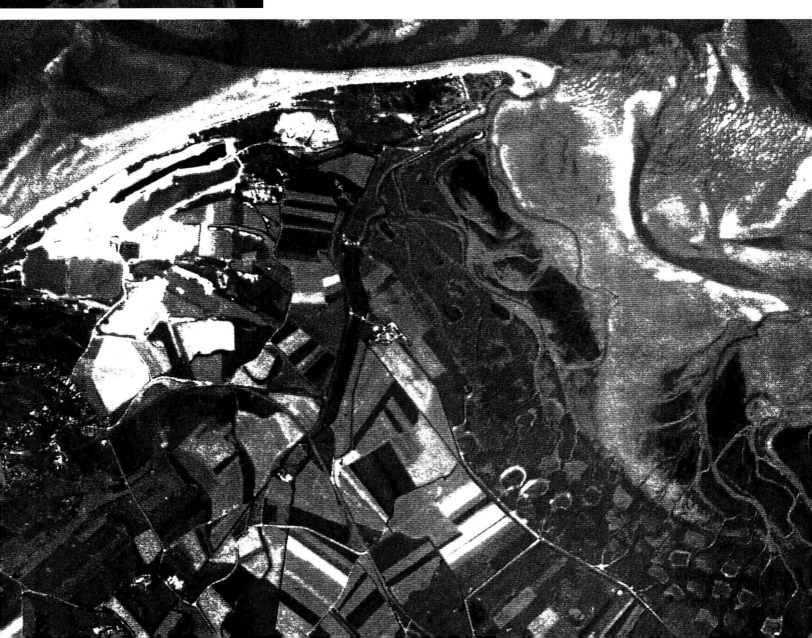

La Pointe du Hourdel, which marks the western-most tip of the bay of the Somme (opposite top). Aerial view that reveals areas of deep water formed by currents. The eastern part of the point is scattered with natural "hunting ponds," which are periodically flooded by the tide (bottom).

The four areas involved in the project (right): the "hunting ponds"; the rock deposits that characterize the western part of the point; the small farm holdings; and the town of Le Hourdel.

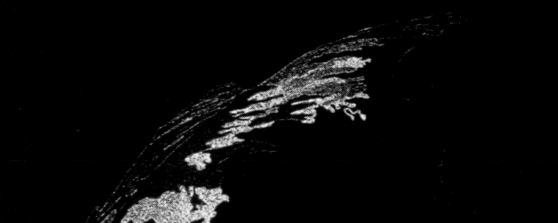

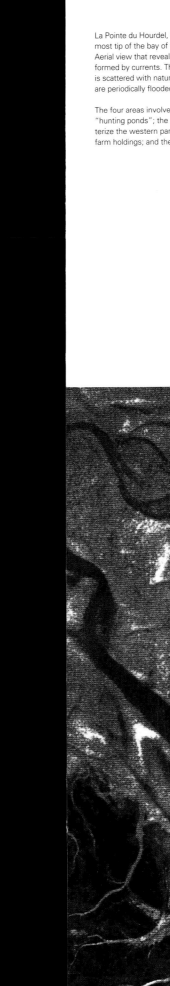

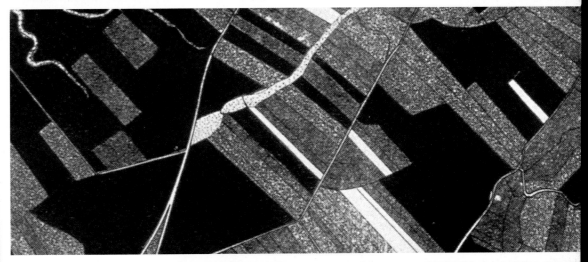

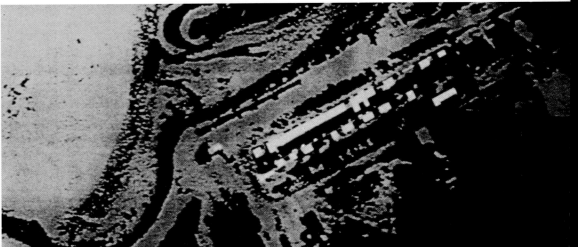

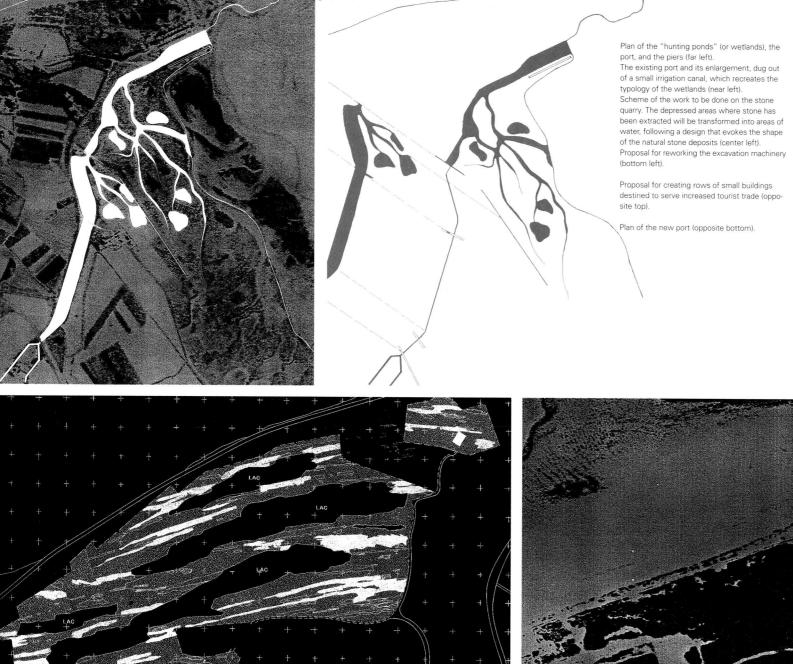

Plan of the "hunting ponds" (or wetlands), the port, and the piers (far left).
The existing port and its enlargement, dug out of a small irrigation canal, which recreates the typology of the wetlands (near left).
Scheme of the work to be done on the stone quarry. The depressed areas where stone has been extracted will be transformed into areas of water, following a design that evokes the shape of the natural stone deposits (center left).
Proposal for reworking the excavation machinery (bottom left).

Proposal for creating rows of small buildings destined to serve increased tourist trade (opposite top).

Plan of the new port (opposite bottom).

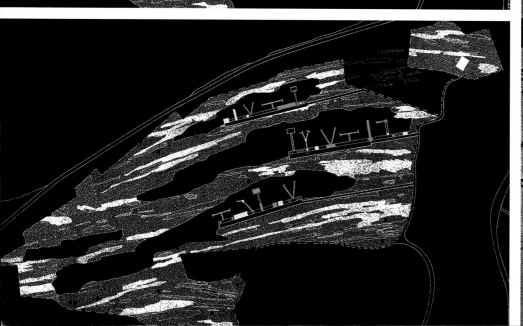

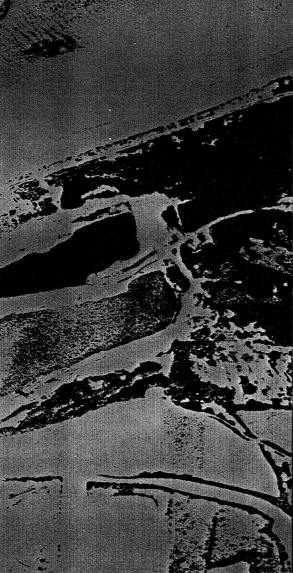

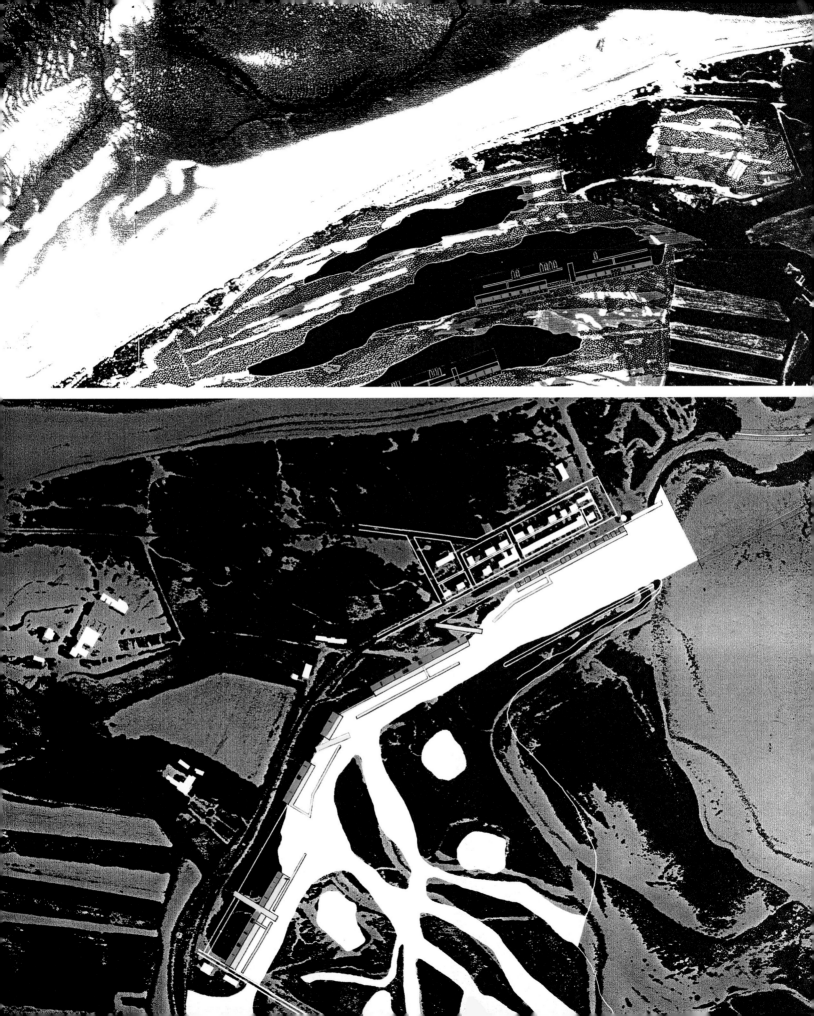

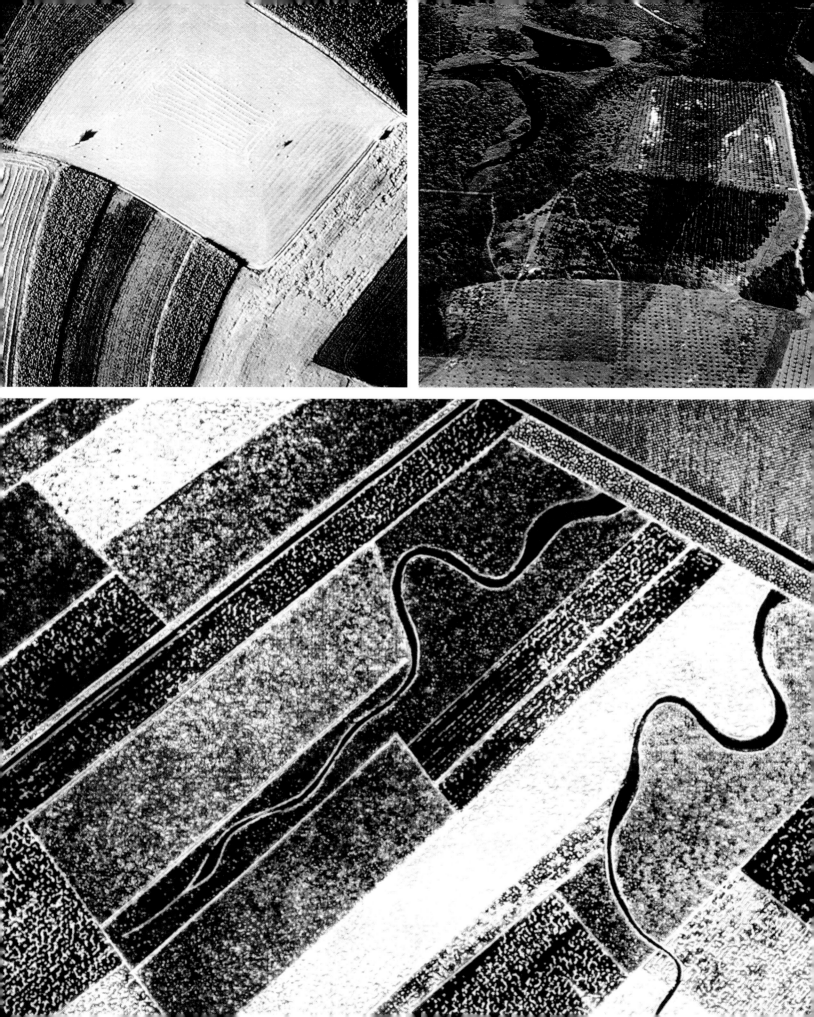

Agricultural plots in the surrounding area (opposite) provide inspirational images for the construction of parking lots near the town.

The project proposes small, lightweight, low-cost houses made of painted wood to be constructed in rows along large wooden wharves (right). A typical fisherman's house from Norway's Lofoten Islands could be used as a model (below).

COUPE DE PRINCIPE PORT DE PECHE

HABITATION EXISTANTE DU HOURDEL TROTTOIR VOIRIE PROMENADE PIETONS CIRCULATION PECHEURS CABANE DE PECHEURS EN BOIS QUAI EN BOIS

COUPE DE PRINCIPE VILLAGE DIGUE PORT DE PLAISANCE

VOIRIE STATIONNEMENT EQUIPEMENTS ET HABITATIONS EN BOIS QUAI EN BOIS PONTONS FLOTTANTS

ELEVATION DE PRINCIPE VILLAGE DIGUE PORT DE PLAISANCE

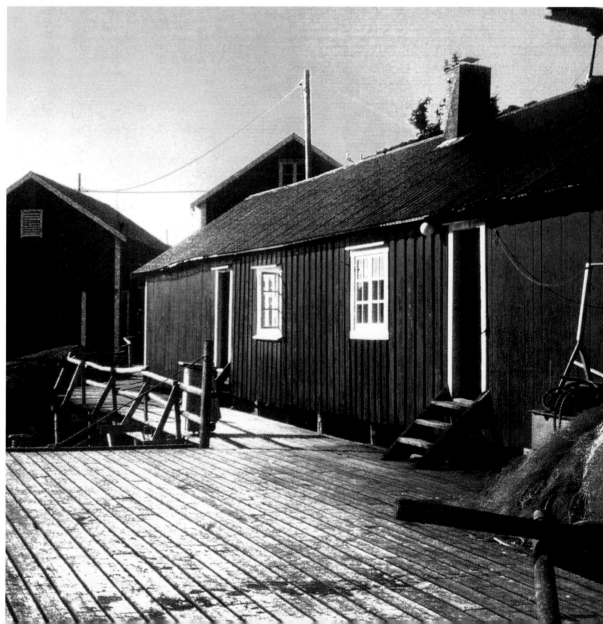

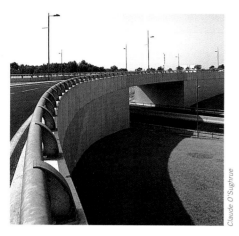

Claude O'Sughrue

Avenue Pierre Mendés-France, Montpellier. This project involves an area of the city only recently developed, with latter-day architecture, and it will serve to establish the construction principles to be eventually employed to unify a series of city quarters running from west to east: Consuls de Mer; the Richter Quarter and its park; the park of the gardens of the Lironde; the Parc Marianne and its nearby quarters; the Parc Héliopolis; and the Millémaire II recreational sports park. The preexisting plant structure is widely scattered and fragile. The landscape preserves traces of ancient holdings, isolated stretches of boundary rows and woods. The project will maintain and reinforce this special lexicon of marks and lines, avoiding all recourse to expediencies that would betray what was here before and so repeat the typical treatment common to all the *ville nouvelles*. The landscape is divided along two broad axes: discontinuous alignments of broad-leaved trees provide guidelines leading east to west, and pine woods mark off broad areas lying to the north and south in less structured valley regions and along rivers. Work is already under way on three large sections: avenue Pierre Mendés-France, which is the main access route to the city, the park on the Lez in the Richter ZAC (Zone d'aménagement contrôlé), and finally the principal artery C10. Work will soon proceed on the restructuring of Parc Marianne, which will involve the rapid creation of a retention basin for the water from the Lironde and the Lez. This portion of the project, which involves a surface area of about fifteen acres, will permit better control of river flooding. **2,964 acres**

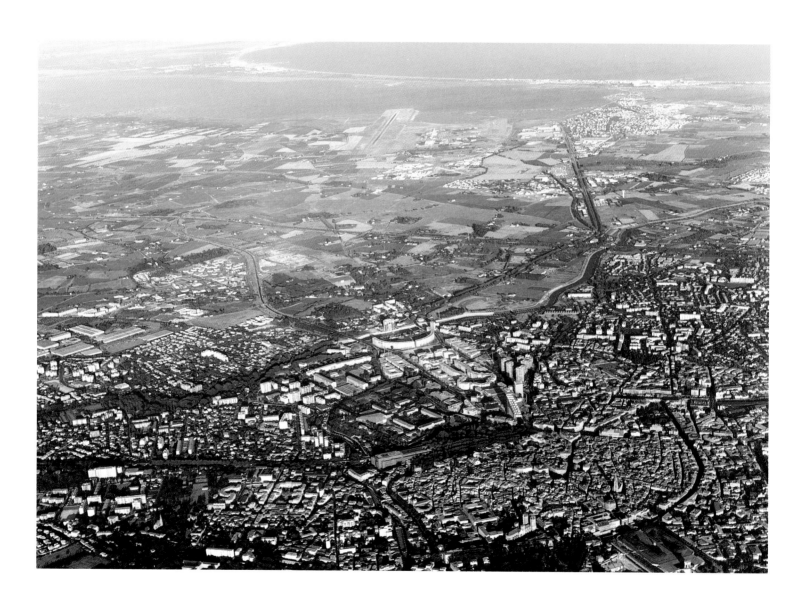

The Zénith traffic circle (opposite top).
Aerial view (opposite bottom). At the center is
the quarter planned by Ricardo Bofill on the two
banks of the Lez River.

Diagram of the primary (red) and secondary (yel-
low) plant structure (right).
Plan of the landscape (below).

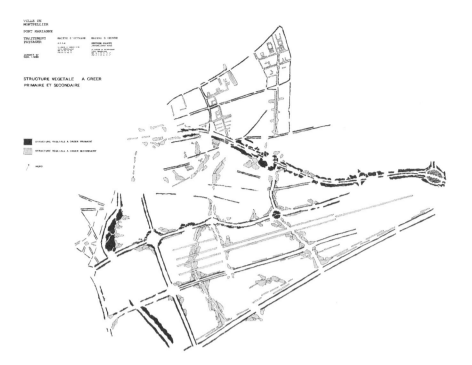

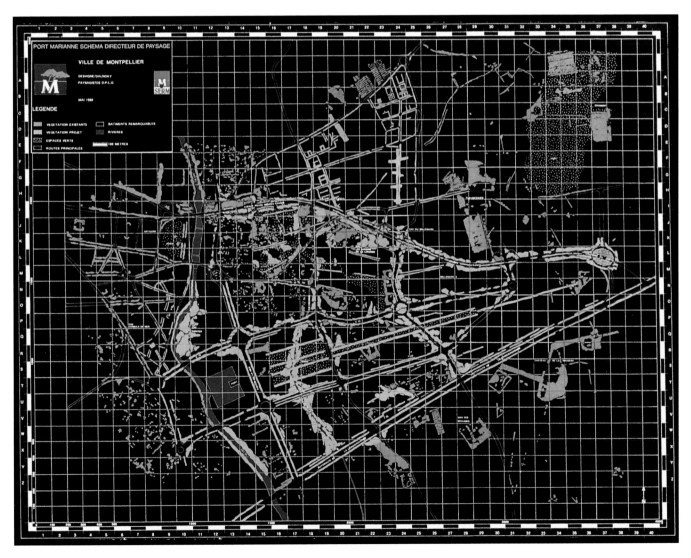

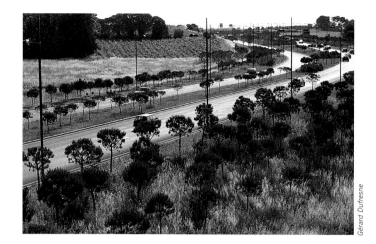

Gérard Dufresne

View of avenue Pierre Mendès-France (left).
Axonometric (below) and aerial view (bottom).

The Zénith traffic circle (opposite).

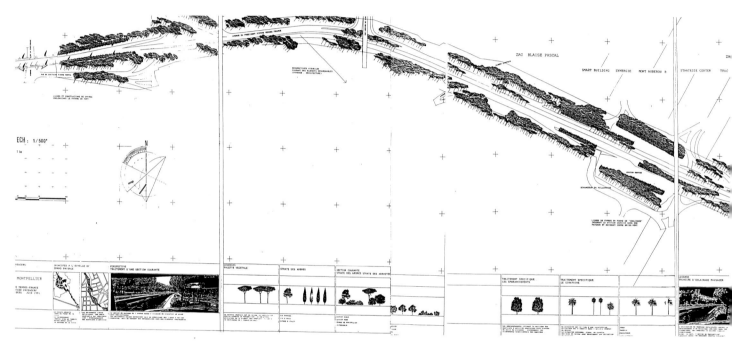

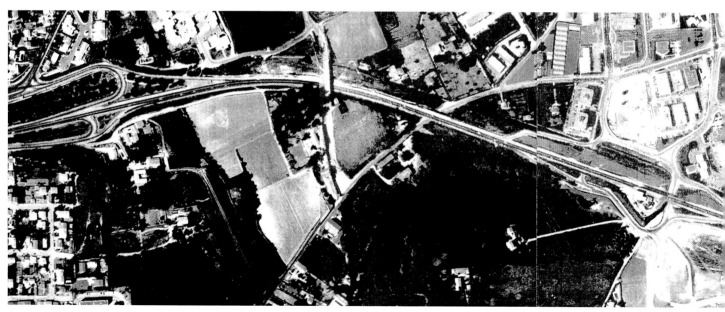

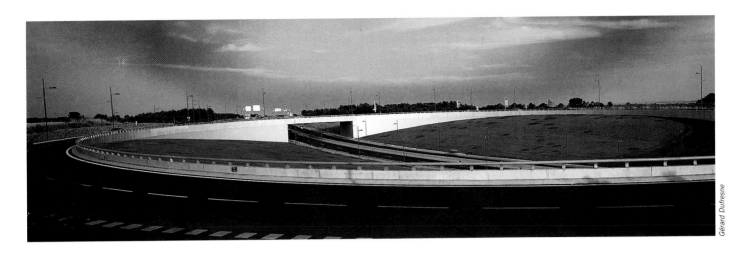

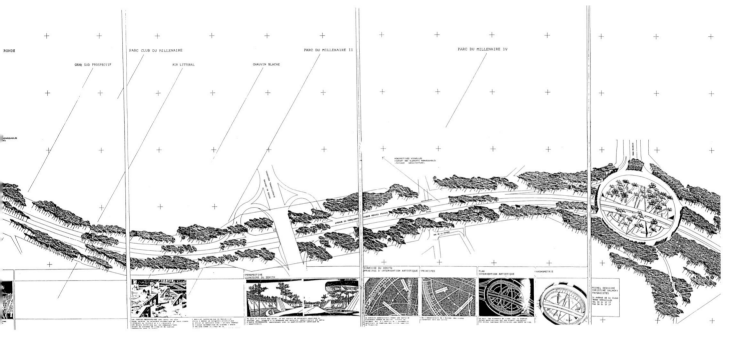

Christine Dalnoky was born in Neuilly-sur-Seine in 1956.
From 1974 to 1978 she studied architecture at the Ècole Nationale
Supérieure des Beaux-Arts in Paris. From 1978 to 1982 she studied
landscape architecture at the Ècole Nationale Supérieure du Paysage
in Versailles, where she earned a DPLG landscape design degree.
Between 1983 and 1987 she collaborated regularly with landscape
designers Alexandre Chemetoff and Michel Corajoud. In 1987 she
won a competition held by the architecture division of the Académie
de France in Rome, and from 1987 to 1988 she was a guest of the
Villa Medici (*Eléments de jardins. Voyage en Italie*, Rome: Villa
Medici, January 1988). Since 1985 she has directed a studio at the
Ècole Nationale Supérieure du Paysage in Versailles, and in the years
1994 and 1995 she was a visiting professor at Geneva's Institut
d'Architecture.

Michel Desvigne was born in Montbéliard in 1958.
From 1977 to 1979 he studied natural science at the Faculty of
Science in Lyon, where he earned a diploma in botany and geology.
From 1979 to 1983 he studied landscape architecture at the Ècole
Nationale Supérieure du Paysage of Versailles, where he earned his
DPLG diploma. Between 1983 and 1986 he collaborated with land-
scape designers Alexandre Chemetoff and Michel Corajoud. Since
1985 he has directed a workshop at the Ècole Nationale Supérieure
du Paysage in Versailles. In 1986 he won a competition held by the
architecture section of the Académie de France in Rome, and from
1986 to 1987 he was a guest of the Villa Medici (*Les jardins élémen-
taires*, with Gilles Tiberghien, Rome: Carte Segrete, December
1987). In 1988 he won a scholarship from FIACRE, Ministére de la
Culture, France, to work on his research. In 1993 he was visiting pro-
fessor at the department of architecture of the Ècole Polytechnique
Fédérale of Lausanne. In the years 1994, 1995, and 1996 he was vis-
iting professor at Geneva's Institut d'Architecture.

Desvigne & Dalnoky
Michel Desvigne and Christine Dalnoky formed their association in
1988. Their studio collaborates with numerous architects (Renzo
Piano, Norman Foster, Valode et Pistre, Paul Andreu, Jean-Marie
Duthilleul, Jean Nouvel). They conduct research for various public
institutions (SNCF, Aéroports de Paris, Air France, Directions
Départementales de l'Equipement, RATP, Ministére de la Culture)
and collaborate regularly with the city councils for public works in
Paris, Lille, Lyon, and Montpellier.
Their projects have been published in numerous architecture maga-
zines: *AMC Le Moniteur architecture*, nos. 35, 44, 52; *Le Moniteur*,
n. 4735; *Architecture d'aujourd'hui*, n. 262; *Techniques et architec-
ture*, n. 407; *Casabella, nos. 597, 598; Lotus international*, n. 87;
Topos, nos. 1, 15). Together they edited the essay *"Parcours dan le
paysage des Hauts de Seine,"* in Topos, n. 13, ed. C.A.U.E., 1992.
Desvigne and Dalnoky have participated in many exhibitions. The
catalog of the exhibit "Het Landschap, the Landscape," held at the
Singel Foundation in Antwerp in 1995, was published by
International de Singel.

Interior garden of a condominium in rue de Meaux, Paris.
Client: R.I.V.P.
Design: Michel Desvigne, Christine Dalnoky (landscape); Philippe Converuy (project management, landscape); Renzo Piano (architect)
Work completed October 1990

Place des Célestins, Lyon
Client: competition held by the Ville de Lyon
Design: Michel Desvigne, Christine Dalnoky (landscape); François Neveux, Bernard Rouyer, Pauline Lévy (project management, landscape); E2CA (engineering)
Competition, 1991; work completed December 1994

René et Madeleine Caille public garden in the Ètats-Unis Quarter, Lyon
Client: Ville de Lyon
Design: Michel Desvigne, Christine Dalnoky (landscape); Bernard Rouyer (project management, landscape); Tony Garnier (architect); E2CA (engineering)
Work completed winter 1992

Square de la Couronne, Nîmes
Client: Ville de Nîmes
Design: Michel Desvigne, Christine Dalnoky (landscape); Bernard Rouyer, Pauline Lévy (project management, landscape)
December 1994

A system of public spaces for the T1-Seine Rive Gauche Quarter, Paris
Client: S.E.M.A.P.A.
Design: Michel Desvigne, Christine Dalnoky (landscape); Bernard Rouyer, François Neveux (project management, landscape); S.E.E.E., Ingénieurs & Paysages (engineering)
Studies began May 1994; work in progress

Urban park on the banks of the Théols River, Issoudun (Indre)
Client: Competition held by the Ville d'Issoudun
Design: Michel Desvigne, Christine Dalnoky (landscape); François Neveux (project management, landscape); E2CA (engineering)
Competition, November 1992; work completed September 1994

Reworking of the Lustgarten, Berlin
Client: Invitation of Grünberlin
Design: Michel Desvigne, Christine Dalnoky (landscape); Bernard Rouyer, François Neveux, Pauline Lévy (project management)
Spring 1995

Tourist complex in an abandoned quarry on the bay of Sistiana, Trieste
Client: FINSEPOL
Design: Michel Desvigne, Christine Dalnoky (landscape); Bernard Rouyer, François Neveux (project management, landscape); Renzo Piano (architect)
1991-93

Park for the new quarter adjoining Sagrera train station, Barcelona
Client: The Travelstead Group
Design: Michel Desvigne, Christine Dalnoky (landscape); Pauline Lévy, David Besson Girard (project management, landscape); Norman Foster (architect)
December 1991

Landscaping for new TGV Méditerranée stations at Valence (Drôme), Avignon (Vaucluse), and Marseille (Bouches-du-Rhône)
Client: S.N.C.F. (Société Nationale des Chemins de Fer Français)
Design: Michel Desvigne, Christine Dalnoky (landscape); Bernard Rouyer, François Neveux (project management, landscape); Jean-Marie Duthilleul, M. Bajard (architect and engineer)
Spring-summer 1995

Landscaping and parking areas for the Thomson Factory, Guyancourt (Yvelines)
Client: Thomson Company
Design: Michel Desvigne, Christine Dalnoky (landscape); Bernard Rouyer (project management, landscape); Renzo Piano (architect)
First phase of work completed March 1991; second phase completed spring 1992

Access-roads treatments for Roissy-Charles de Gaulle Airport
Client: A.D.P. Aéroports de Paris
Design: Michel Desvigne, Christine Dalnoky (landscape); François Neveux (project management, landscape); Paul Andreu (airport architect); E2CA, Ingénieurs & Paysages (engineering)
Work completed spring 1996

Landscaping along rail viaducts over the Rhône River at Avignon (Vaucluse)
Client: S.N.C.F.
Design: Michel Desvigne, Christine Dalnoky (landscape); Bernard Rouyer (project management, landscape); R.F.R. (engineering)
November 1994

Study of the future of Pointe du Hourdel, Cayeux-sur-Mer (Somme)
Client: Competition held by D.D.E. maritime of the Somme
Design: Michel Desvigne, Christine Dalnoky (landscape); François Neveux (project management, landscape)
May 1993

Avenue Pierre Mendés-France, Montpellier (Hérault)
Client: competition held by the Ville de Montpellier
Design: Michel Desvigne, Christine Dalnoky (landscape); François Neveux, Pauline Lévy (project management)
Competition, June 1991; implementation, spring 1992-93

Printed and bound in Italy by Arti Grafiche Motta, Milano.